In Support *of my* Self

A Woman's Guide to Asking for and Accepting Help from Others.

by

Cheryl Gray Hines

Watersprings
PUBLISHING

In Support of Myself
Published by Watersprings Publishing, a division of
Watersprings Media House, LLC.
P.O. Box 1284
Olive Branch, MS 38654
www.waterspringsmedia.com
Contact publisher for bulk orders and permission requests.

Cover Design: Carmelle Scott, Longtail Graphics

Printed in the United States of America.

Library of Congress Control Number: 2020916743

ISBN-13: 978-1-948877-54-1

Table of Contents

*I dedicate this book to my Mom
Fannetta "Pat" Gray.*

*You were my role model for living
a life contributing to others.*

*Your passing inspired the completion of this book and your
encouragement to fully embrace being in support of myself.*

Thank you...

Praises for In Support of Myself

If you are anything like me and are often identified as a high-capacity person that somehow finds a way to "get it done" by any means necessary, this is the book for you! *In Support of Myself* not only allowed me to identify patterns- their root, and the impact they have had on my ability to fully be present, embrace, and excel in all areas of life, but also provided me with knowledge, tools, and actionable steps needed to evaluate and make necessary adjustments. I was thoroughly informed and affirmed; my life and perspective will never be the same!

DANIELLE JONSON
Vice President

There are many life enriching concepts presented in this book. The chapter "No is an Equalizer" challenged me personally and I loved the self-reflecting questions at the end of each chapter.

JOY CLARKE-HOLMES
Retired Corporate Executive

In Support of Myself is a highly relatable, impactful text that connects with women in every season of life, affirms them, and pushes them to their best. Comparatively short in length but loaded with nuggets of wisdom and carefully curated reflection questions, this book will inspire deep personal reflection and produce needed transformation. If you think you can do it all or, if you feel like you're in over your head, this is the book for you, don't miss it!

KRISTEN VICTOR
Teacher and Mom of Toddlers

Cheryl Gray Hines' *In Support of Myself: A Woman's Guide to Asking and Accepting Help From Others* is one of the finest, most refreshing, renewing, reviving, restorative, repairing, reinvigorating books to guide women through the ups and downs of life with a resource of Deliverance and Healing. Not only does this book bring relief and release to a woman's holistic being, but it also embraces the core and fiber of a woman's heart, soul, mind, and spirit. It lets her know there is Hope for her sanity and mental health. You will never be the same after reading this book. It is a "must-read," and ends with a powerful call to action that grows and develops the reader.

DR. JOAN L. WHARTON
Senior Pastor, Hemingway Temple AME Church

Brenda:

You give to your
family, church, workplace
and community with dedication
from your heart.

Please make yourself
a priority so you can give from
the overflow!

Be in support of
yourself! ♡

With love and appreciation,

Cheryl

Introduction

"No experience is wasted. Everything in life
is happening to grow you up, to fill you up,
to help you become more of who
you were created to be."

OPRAH WINFREY

Yes, I can. I got it. I can handle this. No, I don't need any help. I'm okay. Are any of these phrases common responses or inward thoughts that drive you to take things on by yourself? If the answer is yes, you like me, may suffer from "Handler Syndrome" a.k.a. I can handle it all!

Many women, including myself, struggle trying to be everything to everyone. We discount our needs rarely asking for support from others, or we turn down offers of support. I have watched girls from teenagers to women in their eighties play down that the needs they have are worth supporting. Well, my sista, you don't have to take on everything on your own. You are worthy of being supported by others. In fact, I'm sure there are people around you who are hoping you will trust them enough to let them come to your aid.

In Support of Myself is an awakening to the fact that we aren't meant to take on life alone, certainly not to the point of frustration, struggle, exhaustion, or depletion. Nor should we exist with regret from pouring out emotionally, physically, spiritually, or financially beyond what we truly are able to give. We sometimes take on life as if only we can do it, even with family, friends, and others in our lives willing to help. By acknowledging and accepting our limitations we

can identify our needs, ask for, and accept the abundant support that's available to each of us.

We are here to have an impact and make a difference in this world. That means different things at different times of your life, such as focusing on finding your life's direction, pursuing your career, providing a foundation for your children, cultivating a relationship or marriage, or deepening your spiritual walk. The key is to recognize that supporting yourself is critical to living your life to the fullest. Being in support of yourself is not about being selfish but realizing that being your best with ease and finding joy requires not being an island, discounting your needs, or ignoring the current phase of your life journey.

Women Need the Support of Others

In December 1994, death was knocking at my door. I was admitted into the hospital with my lungs functioning at 50% and diminishing daily as my condition worsened. It was then the title and the concept of this book was born as I struggled to have enough breath to walk from my hospital bed to the bathroom. From deep inside me, I heard, "now you'll have to ask for support." It has taken me twenty-five years to discover, experience, and embrace the never-ending journey of being in support of myself. It has required dismantling the generations of examples that have informed my behavior, a belief that it was indeed the only way to conduct my life, and the fear of trusting others enough to let them in and help me with my life journey.

My mother passed in 2012. The last few years of her life she quietly suffered, sharing with only a few close friends her health struggles and dire condition. As her buddy Ms. Mary told me, she put on her best face to mask her plight when visiting us or when we visited her. I would have wanted to support her if I had known.

As I reflected on my mother's last decisions, they were fully in support of herself. She told me to come to South Carolina immediately before the rehab facility she was in ended her life and bring her back to Maryland. She had resisted for over a month coming to Maryland, not wanting to be a bother or lose the semblance of control in her life. Little did we know, she was septic when she had to pass a fitness

test to be released from rehab. She somehow willed the strength to get through the test. I vividly recall the eight-hour drive home stopping once at a hospital in North Carolina because it looked like I was losing her to the grips of death. She demanded that I get her to Maryland. I then stopped one other time for gas and to get food for my young daughter.

When we arrived in Maryland at the facility where my mother was to finish her recovery, she was in excruciating pain. The next day she was admitted to the hospital because of her dire condition. However, she had made it to where she could be close to family. She knew in her heart that she would never leave the hospital because she told me so.

Several weeks had passed, during which, the doctors had to revive my mother twice. The doctors asked if she had a living will and if not, should they continue procedures to keep her alive. I stood at her bedside gripped with dread over the gravity of the decision. Not realizing she was conscious, I said, "Mom, I don't know what to do and described the choices the doctors had placed in my hands of invasive life-saving procedures or letting her pass. She opened her eyes and whispered, "ENOUGH." She had made the decision. I told her I loved her and she whispered she loved me back. I gently kissed and stroked her forehead as I sung to her until she was gone.

In the end, she had transcended from primarily considering others to considering what she wanted which was being surrounded with the love of family and friends to the end.

Far too many women who pretend they are fine when they are struggling in some area of their lives. I see other women suffer and struggle with health issues, loss, financial challenges, complexities with children, parents, spouses, relationships, work or other life challenging issues. A better life is available when we just acknowledge our needs and ask for support. You deserve a fulfilling life that enables you to impact others from a place of wholeness versus depletion.

In Support of Myself will help you explore self-limiting beliefs and what gets in the way of you asking for and accepting support from others, define what matters most to you, and enable you to determine the various areas of your life that need support. Women are beautiful and complex creatures and there are many parts of us in

need of support. The search to connect with what you truly need will enable you to open yourself up to asking for and accepting support from others. My hope and prayer for you is that you will be able to embrace the journey of supporting yourself so you have the capacity to profoundly impact and support others.

CHAPTER 1

The Women Behind Why
I Am Supportive of Others

"My passion for giving is no different than yours. I give because it's in my heart to give. I give because I was taught to give at a very early age. This is how I developed my passion for giving."

JACKIE JOYNER-KERSEE

There were three generations of women I was influenced by in my formative years who contributed to me becoming a very strong and independent woman. I learned from them the importance of education, being able to stand on your own, not showing weakness, accomplishing goals, taking pride in your appearance, managing your emotions, loving and caring for your family, as well as giving back to your community.

Great grandmother Parrish, "Grams," was an adoring mother to my Grandfather Dr. C.J. Parrish. I remember her in her late eighties to early nineties when she passed. She was a widow, had lost her beloved famous jazz musician son, my Great Uncle Avery Parrish when he attempted to break up a bar fight where he sustained a brain injury that led to his death. Grams was an amputee who was unstoppable, a force in her own right with a powerful personality. She was an example of maintaining enthusiasm for life and not letting your circumstances get the best of you. She helped my mother buy her first home after her marriage to my Dad ended.

Then there was great grandmother Farley who was a freed slave and raised six children (four girls and two boys) in Birmingham, Alabama. They all left the south as young adults moving to Harlem and Washington, D.C. None of my grandmother's sisters had children, yet they all worked hard, contributed to helping their families and others. She was in my life until the age of 101. I was told about the sacrifices she made and the strength she exhibited to ensure her children had a better life.

Great Aunt Alice cleaned homes and department store bathrooms, yet was full of joy, had hearty laugh, served her community, and contributed to paying for the education of others. Great Aunt Leola had a business in Harlem, was a widow whose husband was murdered. I remember her as a very stylish yet tough woman who helped others when she could. Great Aunt Maude had two brownstones very close to the Capitol in Washington D.C. that provided accommodations for entertainers on the Chitlin' Circuit. She always welcomed family, had a place for us to stay, and cared for great grandmother Farley until her death. The three great aunts insisted that their baby sister Florence, my grandmother, have a better life and ensured that she attended Tuskegee Teacher's College in the late 1920s. I remember my great aunts as having done well for themselves but doing so very much alone and not wanting to lean on others for help in their declining years.

My Grandmother, affectionately known as Nanny, was college educated in the late 1920s. She went on to run one of the first professional development training programs for black women in Queens, N.Y. When my Grandfather C.J Parrish accepted a role as head of the Department for Aging for New York State, he and Nanny moved to upstate, New York where she became one of Governor Rockefeller's executive assistants. In my early teens, I spent many summers with my grandparents learning social graces, attending events, going to church services, getting exposure to the arts, learning the importance of serving others. It was during those teen years I lovingly named my grandmother the Rock of Gibraltar after learning she had been walking around with two chipped spinal disks from a fall and had never seen her wince. She was devoted to her family, accomplished, highly respected in her church and social circles, a leader in the Links organization and her church, always

My mother Fannetta "Pat" Gray was one of the most giving people I have ever known in my life. She was born in Birmingham, Alabama and lived there until she was twelve years old. This was the end of the depression era and a time when racial segregation was a day-to-day reality in all facets of life. She learned at a very young age how to stay in her place, suppress her voice, and negate her needs. When she moved to New York City at thirteen, my grandmother charged her with the responsibility of caring for her brothers. She was the oldest of three siblings and was like a mother to her youngest brother Lloyd who was thirteen years younger. She was also expected to pursue excellence in education and was taught social graces as a debutante. Mom went to Oswego University where she obtained her Bachelor of Arts degree. She went on to become a librarian. She twice married the love of her life, my dad George Gray. She became a single Mom with elementary school age kids, managing my brother recovering from open heart surgery, living in a new home. She also changed her career to an elementary school teacher. It was during this time that she began teaching me to cook, clean, and do other chores to help maintain our home.

She was quite selfless despite all that she had going on and she made sure my brother and I were exposed to the arts, culture, and enriching summer experiences. Some of my fondest memories were of visiting museums, art galleries, Central Park in the summer, and Rockefeller Center at Christmas in NYC. She maintained a beautiful home with a lovely garden outside and hosted fellow teachers for lunch and had bridge parties with friends. Because of how she seemed to effortlessly

go about life, it's hard to believe that during this period she also had financial and emotional hardships.

She was in her seventies by the time I learned that she had developed a serious health condition in her thirties that she battled for the rest of her life. I remember the car she drove when I was in third grade. It had a rusted-out floor in the backseat covered with a rubber mat. I thought it was fun until the car finally broke down in the snow and we had to endure a cold long walk before finding warmth. A couple of years prior to my Mom passing I was sharing the favorite meals she had cooked when I was growing up that I had not enjoyed in a long time. When I told her ham hocks and navy beans with cornbread was one of my favorite meals she shared that that was one of the meals she made when money was very tight.

There was the sadness in her I saw sometimes. This made me want to be the best I could be at whatever I did.

As a single Mom, she also continued her educational pursuits obtaining a master's degree from New York University while excelling as a teacher, then school Administrator before becoming an Elementary School Principal in Lawrence, New York. I remember seeing her tirelessly pouring over her textbooks on a counter she had built in the kitchen to sit at and study. Throughout my life, she also had leadership roles in her church and participated in civic organizations.

After retiring in her 60s, she moved to South Carolina to assist her parents who were in their eighties and created programs in the county she lived to teach illiterate parents and grandparents to read along with the preschool age children and their families. During this period, she became a member of Delta Sigma Theta sorority and a member of the Links. A constant theme in her life was being focused on improving herself and getting involved in things so she could do for family, friends, and community. She was willing to be in support of everyone else whether financially, with her skills, time, wisdom, or home. Sometimes she was supportive to her own detriment.

These generations of women were role models who influenced my life. From them, I saw love of family, importance of faith in God, giving to others, strength, courage, accomplishments, style, love of music/ theatre/art, and an appreciation of the finer things in life. I rarely saw

my mother or grandmother do things for themselves, expressing their need for support from others, showing physical pain, or emotional anguish.

The Woman I Became from My Influencers

I am often described by others as a candid, smart, generous, someone who is committed to friends and family. I was also told that I have an infectious laugh like my Great Aunt Alice. I have high standards. I am goal oriented and like the finer things in life. I volunteer and give to my church and community like my Mom and Nanny. I am known to have a soft heart for women and all the joys and complexities that accompany our lives. Over the last thirty years, I have done work through programs, retreats, and church ministry to positively impact the lives of women in corporate America, women's organizations, school mentoring programs, and women's prisons. Contributing to the betterment of women's lives, cultivating them as leaders, and encouraging them to thrive has been a consistent thread throughout my life.

A Lifetime of Focus on Women

In my twenties, I was a mentor to young women starting their careers in corporate America and a big sister to young ladies in juvenile delinquent homes. In my thirties early forties, I created and led corporate initiatives that retained and developed women, coached executives and other leaders, led workshops for corporate women's affinity groups, and served as a member and on the Board for the Coalition of 100 Black Women. In my forties and early fifties, after leaving corporate America I continued coaching women in senior leadership positions and mentored young women while also leading ministries for my church nursery, women's retreats, and Celebrate Recovery Program for eight years at the Maryland Correctional Facility for Women. For decades, I have hosted gatherings for women to soothe their soul as well as bring joy and laughter to their demanding lives. Now is the season that I am pouring into women through writing and speaking to support them being their best selves.

I am a wife, mother of one daughter by birth and another from the

love of my life. I have been a single mother, divorcee, survived life-threatening illnesses, and rape. I have lived through the deaths of both my parents and other cherished family and friends. I have traveled a twenty-year road of challenges and successes up the corporate ladder rising to the director level at P & G. I taught for eight years at the Johns Hopkins University Carey School of Business. For almost two decades, I have experienced the trials and tribulations of being an entrepreneur which has its high and low points, including not knowing from where my next check would come. I've contributed to the transformation and development of leaders at all levels of organizations as a coach, trainer, consultant, and as the CEO of C. Gray & Associates, focusing on integrity, leadership/organization development, and coaching.

Honesty is a core value in my life. It fuels my passion for integrity and encouraging others to strive for new levels of integrity in their lives. Most importantly, I am a woman of great faith and I deeply love God. I believe God has given me all of these experiences so I could relate to women in many different stations of life.

I have witnessed that no matter what level or station of life women are in, many are trying to navigate life on their own. These experiences and interactions with women have taught me that life is much better when we open ourselves up to the support of others who want to contribute to our lives.

Reflections

- Who are key women that have influenced who you have become?
- What were the characteristics and beliefs of the women who influenced you?
- What did these women role model that has influenced your beliefs and actions?

Reflections

CHAPTER 2

Supporting Myself Versus Selfishness

"If you think taking care of yourself is selfish, change your mind. If you don't, you're simply ducking your responsibilities."

ANN RICHARDS

Many women instinctively step up to support someone in need with words of encouragement, helpful advice, information, financial offerings, even personal possessions. However, just as many of us choke up when it comes to asking for support.

Some of you may view being in support of yourself as self-centered or selfish. Let me clarify the difference between these notions. The concept of the being in support of myself does not mean being overly concerned with your own self-interest and doing things primarily for your benefit while having little concern for others. It's also not about a preoccupation with your own thoughts or interests. Anyone who views being in support of yourself in that manner will not be served or enriched by this book.

Rather, being in support of yourself means first recognizing that you're often a giver to the deficit of yourself and that you find it difficult to factor yourself into the equation. Here are some of the many faces of women who would benefit from being in support of themselves:

- The single woman working late and through the weekend has no personal life
- The woman who is struggling to understand some aspect of her work and is concerned about being perceived as incompetent if she doesn't act like she knows
- A successful sista or Mom who is the bank for one or more of her grown kids, family members, or friends. She feels deprived because of her generosity
- The woman who lives alone and who is sick, hurt, and/or depressed trying to make it on her own
- Young mother who just wants to take a relaxing bath alone but can't because she feels uncomfortable asking for help to have precious quiet time
- The woman serving on multiple committees in a leadership role outside of her work who feels burned out
- The woman who gets all the extra projects of underperforming colleagues at work because she delivers, meanwhile stress is quietly wearing her down
- The woman who is hiding her financial struggles and is at the end of herself feeling alone and ashamed to share her plight
- The woman who is enduring emotional or physical abuse and keeps it to herself
- The woman who has survived rape or sexual assault and suffers in silence
- The control queen who really has self-esteem or trust issues but doesn't dare tell anyone
- The single mom who is trying to keep things together so the kids think everything is "normal"
- The woman who believes that it is a form of weakness to have someone step in to help her
- The woman who doesn't feel she is worthy of the support of others
- The woman who feels support is for others who do not have the ability to stand on their own

To be in support of yourself is to recognize that there are times we need other people to assist and elevate us, or help to sustain our courage, emotional state, spirit, body, health, or other areas of need. It means having someone to encourage you, advocate for you, who listens to you, offers guidance, and prays with and for you. It's honoring what you need to do, decide, start, or stop to have the kind of life you want. Being in support of yourself means reaching out to others when you are in need, sharing what you are going through, and making decisions that best serve you.

Tiffany, a young woman in her twenties moving forward quickly on a career track at work attended two weeks of leadership courses I had taught. At the end of the workshops she said, "After all I have learned about leading people and managing organizations, I've decided I don't want to take on the responsibility others are pushing me towards at work." She shared sound thinking, had considered the cost to her career, and had valid reasons for making a decision that supported what she wanted for her life. While some would have disagreed with her decision, I recognized the courage it took for her to go against the traditional "right path" and embrace her version of her best life.

Tiffany embraced the path she had envisioned for herself which included marriage, children, and making a profound difference in non-management positions so she would have more time to enjoy her life. Being in support of yourself means getting what you need, to have a fulfilling life that serves you and others versus being over stretched, struggling, or unfulfilled as a result of choices that are not in your best interest.

Reflections

- Do you view the support of others as self-centered? If yes, then where did that perception come from?
- What beliefs do you have to release to accept others being a support to you or helping you in times of need?
- What area immediately comes to mind where you would benefit from the support of others?

Reflections

CHAPTER 3

Barriers to Asking for Support

"Never underestimate the ruthlessness
of the ego to keep you in a state of suffering
in which you voluntarily participate."

IYANLA VANZANT

t is amazing how we can totally stop ourselves from asking for support with reasons why it won't work. We think someone might be too busy or we don't want to be a bother so we don't ask. The reasons we find can serve as a smoke screen in the form of justifications for not asking for help or disclosing our present struggle. Our reasons are often born out of fear or concern for our image. When fear is permitted to fester and grow it builds up a wall which isolates and blocks us from expressing our needs. Then concerns spring up in our mind that sound like:

- I don't want to be a bother because....
- What if they say no?
- If they don't want to it's because they really don't care about me
- They may say no because I am not appreciated by them
- I am not good enough to warrant help
- What will they think of me? My image will be ruined
- They'll think I'm incompetent if I ask
- I don't want to impose because...

All these reasons that we conjure up are not based on anything but noise in our own minds. We haven't asked the question about whether the person is available, has the time or capacity to help. We make up that the person would be bothered by our request. How many

times this week have you said or heard another woman say that they didn't want to be a bother, impose on, or be a burden to someone? The underlying interpretation is that asking for assistance would be an effort not worth the person's time, and even worse, you may be a source of annoyance.

When you're close to someone in a work environment where someone sees themselves as a resource for you, typically that person is willing and sometimes even honored to help, provide advice, make suggestions, just listen, or offer a much-needed hug. When the time doesn't work for them, they will let you know. In instances that they don't communicate that they have a lot going on, it's because they believe your current need is more urgent or important than their own. It is not unusual to have conversations in our head about what we need, don't want to do, or how overwhelmed we are. However, when an issue remains in our thoughts, there is no hope for it to get better.

I celebrated my birthday this year, in January 2020, before the COVID 19 closures, with a party. I had decided two months beforehand that afterward I wanted to go away on a restorative vacation by myself. I had a one-day client engagement planned the week after the party which was the only week for months that I could fit in a vacation. I initially wrote it off as poor planning on my part and then a colleague who works with the client came to mind. I engaged in a mental battle with myself over whether to call the colleague. What would the client think? Would it seem like I was shirking responsibility? I finally stopped the conversation that was going nowhere in my head when I realized the only way to have what I wanted was to move beyond my thoughts. I hesitantly texted the colleague sharing my situation and they agreed to fill in. I then called the client and presented the potential change which they wholeheartedly supported. It is only when you move beyond your thoughts into the space of expressing needs or struggles that anything has the possibility of changing.

Don't Want to Be a Bother

At one point I thought this perception of not wanting to be a bother was one that was predominantly held by the Baby Boomers and older generations. However, unfortunately, it is a view that is carried across

all generations.

When the word "bother" is used, it's often carrying with it negative implications. To be a bother means being a source of inconvenience or a burden to someone. When you say you don't want to "be a bother" you are diminishing your importance to those who are invested in your well-being. When someone genuinely cares for you it can be hurtful and cause them to wonder what they did wrong for you not to ask them for help. Finding out that you didn't want to bother the person makes matters worse. I have been left in a painful whirlwind from which I had to heal because someone close to me struggled with life issues alone. They did so because they did not want to be a bother. We have to push past the notion that we will be a bother to someone who cares about us.

I remember my mother and friends often saying I don't want to call and bother you because you're so busy. Truth be told, it was at a time in my life when I had way too much on my plate. I'd respond by saying if I'm doing something or eating, I won't answer the phone, or I will call you back. The point is that others can communicate what does and doesn't work for them.

When someone declines a request of ours, we have to try not to take it personally. It may not mean anything more than it being an inopportune time for that person to support our request. It is easier said than done especially when our feelings interpret the response as a form of rejection. We human beings have an innate ability to protect ourselves emotionally and physically. If something seems like it will cause us harm, we stay away from it. As we mature in life, we have more experiences to reference in our minds that we associate with potential negative outcomes. Since we all have experiences that contribute to us conjuring up negative impressions, we need to go into pause mode to discover if how we're feeling is just made up.

Don't Want to Impose

You might have heard or said you didn't want to impose on someone. To impose on someone is to take unfair advantage by exerting pressure on them to do something. If someone can't help you, they'll tell you. It's also fair to say that there are many women who suffer

from the preoccupation of people pleasing which is covered in another chapter. I used to be one of those people because I thought I had to please others to be liked or valued by them. It's us people pleasers who most often assume that we're being an imposition. If someone sees us as being an imposition it is most likely because they made a decision without considering the impact on their time, resources, or life. For some, the decision to help comes from a place of guilt or greed. It is in these instances that helper perceives the person needing help as an imposition.

Danielle is one of those people who prides herself on being a good friend. She is that person who is always asked to drive friends to places, coordinates their social activities, and helps them out in times of need. She often complains about being imposed upon by friends. Her selfless and supportive nature affects her ability to handle her own business and sometimes leads to her feeling burned out. She doesn't consider the impact of saying yes so often and then resents how her choices affect her life. When someone considers a decision and its impact first, they are more likely to recognize that they can make decisions that work for all involved.

I had set up a last-minute date with my husband. Anyone who has many life demands knows that getting out with your honey can be a challenge. During the same time, I had forgotten I was supposed to take my teenage daughter to the hairdresser to prepare for school pictures the next day. And a girl needs her hair right for yearbook pictures. So here I am with two commitments and in need of HELP!!!!

Asking for help at the last minute felt like an imposition. I reached out to my mother-in-law and two girlfriends who were all busy. So, the chatter started in my mind. "See, when you take a risk to ask for help, nobody is there when you need them." Wrong. I made up a story about why the reasons that were offered should be taken personally versus acknowledging that these people were not available. It just so happened that my friend Denise had asked for an hour of my time to run through a presentation she had to make. I still have challenges with managing my time when I am already pressed, so, of course I said yes, which ended up being a blessing in disguise.

When I got to her house, she saw that I was distraught and she let

me vent about how ungrateful my husband and daughter were and how I was trying to work things out in a way that worked for everyone and how they were all only thinking about their own needs. Bless her heart, she listened for a few minutes shelving her agenda and finally said, "Well, honey, I can take your daughter to the hairdresser so you and your boo can have your date."

My response was predictable, "I don't want to impose because you live fifteen minutes away." Five minutes later I realized I had rejected an offer of help because I didn't want to impose. After I had a reality check, I gladly accepted the help which she graciously provided.

This idea of imposing is a two-way proposition. On one side we don't want to impose on others. On the other side, we can make decisions that cause us to feel imposed upon. There are times when we have to step up and deal with emergency situations that don't allow us to fully consider the repercussions of a decision. They may later require a new set of decisions, so we do not feel imposed upon.

On more than one occasion I have had a sista complain about being imposed upon by a family member or friend. Maybe the person came to them multiple times for money to pay a bill when they overextended themselves or decided to visit with them longer than originally agreed. There are times we may feel powerless when someone makes a request of us, but don't buy the hype. We all have the power of choice. It's a question of whether we exercise it after considering the cost of the choice.

When we are on automatic pilot and decide to offer our assistance rather than considering whether helping someone is a wise choice, we may end up feeling imposed upon or taken advantage of. It is essential that we strive to make decisions work for us and others, not just others. We all can exercise choice in our decision making which is a form of personal power.

Fear of Rejection

The many faces of fear can immobilize us from asking for help. We can experience a fear of rejection in such an intense way that if someone says no to us, we interpret it as if we are not as important as we imagined we were to them. In most instances, unless we have created

some fantasy about the depth or level of relationship, it's simply not true that those who care about us will reject us without good reason. Fear of rejection has caused me to make decisions especially related to relationships that caused misery for me and the other person. I have had friendships and relationships where my perception was that if I didn't meet their expectations it would have a negative effect on the relationship causing them to reject me in some way. For instance, there have been situations when I have not shared that I didn't want to do something out of concern that the person would shut down interacting with me because they're disappointed in me.

From time to time we can live within our own fantasy and then there are times when rejection is real. Very early in my professional career I had the misconception that all leaders in positions of authority wanted those they led to be successful. I was being trained by someone who wouldn't respond to my questions, made jokes about me in public, and communicated with me in a demeaning manner that caused others to apologize for his behavior. The rejection from that person was real. I was under the illusion that I should have been treated differently. In reality, leaders are human and, at times, can act poorly. As none of us want to be rejected, when we are, it can stop us in our tracks from airing our feelings or asking for support.

The key is to move forward in the face of our fear of rejection and recognize there are some who will have valid reasons for declining our requests and a very small number of people with negative intentions. Let's not to let the few with ill-intent cause us to function with fear of rejection.

Vulnerability Is Not a Good Look

Another fear that gets in the way of asking for support is the concern that we will expose our vulnerability, our weaknesses, or inadequacies. It can be something as simple as asking for someone stronger to lift something we are struggling with or acknowledging when we don't understand something or we are sick, tired, or emotionally drained and need someone to step in and help out.

The anxiety of being perceived as not being able to handle something or being thought of as incompetent can lead to concern about how you

may be negatively viewed by others. At work, in new environments, and unfamiliar situations many of us all too often act like we know or we "fake it till we make it" out of fear that that others will discover what we don't know. Consequently, we avoid asking for support. There are times we can make it through with that approach. However, it takes valuable time and comes with greater risk. Unless you are in an environment that discourages asking for guidance, ask your questions versus making up in your mind that your questions will be met with disapproval and indifference.

Let's face it. When we are taking on anything new in life whether it's being in a committed relationship, going to college, starting a new job or volunteer role, having/adopting/fostering children, it means you'll need guidance, support, and patience. Unfortunately, in western culture there is the perception that we should act like we know what to do in new situations. Sure, it's reasonable to think we can draw on past experience, however, that's not always helpful. Pretending is not a way to be successful at new things. A better approach is to seek the support of others and learn from them.

Nobody Can Do It Better Than Me

Another barrier to asking for help is the belief that nobody can do it like me so why bother. Well, my sista, that is true that nobody can replicate what you do because you, my dear, are one-of-a-kind and special like nobody else in this world. It doesn't mean that another person can't contribute in their own way and help to alleviate the enormous weight you're carrying because you're trying to do it all!

When thinking about doing things on my own, chopping onions comes to mind. I love entertaining and when preparing for an event I would want everything to be done in very specific ways so I could count on having a fabulous event. You might say I was a bit of a perfectionist. If someone asked to help with the cooking and the dish required onions, no matter how skilled they were at cooking, I meticulously showed them how to chop the onion my way. I could have just said chop it is small as you can and be done with the request. I think of the time it took to demonstrate and instruct someone to chop onions and how it may have demeaned them from my lack of confidence with a small

task. If it was someone new to cooking that may have been a reason to take that approach, however, most folks I let help in my kitchen could already cook well.

I have learned to ask for help with small stuff because having it done exactly my way isn't going to compromise the outcome and frankly, it really doesn't matter. There are so many things you hold on to do that someone else could help with or do entirely. Their assistance could free you up to have more time for you to do something else. You might have to let go a little, so you can live a lot more.

The Illusion of Perfection

Being perfect is to be flawless and without any shortcomings. Perfectionism is an absolute standard which can be unrealistically high. It demands everything be held to that high level and nothing less. The illusion of perfection is the demeanor some women attempt to portray which is hard to maintain and be supported by others.

Another area that gets in the way of asking for help is trying to maintain the persona that we are perfect. No matter how put together you try to be, you will never be perfect. We are evolving creatures, especially us women. It takes a lot of energy and frankly, it's exhausting, to keep up the image that we have it all together and don't need support in our lives.

I remember during my twenties and thirties I wouldn't leave the house without every hair on my head being in the right place, my outfit impeccable and fully coordinated with the colors, shoes, handbag, jewelry, watch, and even underwear to match. I know that's over the top but that's how I rolled. I had a great car, home, and job. From the outside, you would think that I had the perfect life. I looked at others through my lens of perfectionism often very critical of other people. I seemed like I didn't have a care in the world and I put up a wall to maintain distance from anyone getting too close. The persona of being perfect created a barrier that made me quite unapproachable. Little did others know, I was struggling with many parts of my life. I felt very lonely and I was very insecure. In my twenties, I tried to escape the madness with weed and alcohol. It takes energy to maintain a front. It diminishes your life versus adding to it. And when you aren't authentic, it can cause you to

avoid letting people into your life who can support you for fear that they will see you for who you are. Life can be quite lonely without others to support us through the ever tumultuous and challenging experiences in the journey of life.

Things to Remember About Barriers to Support

- Concerns about asking others for help lead to reasons we make up in our minds for why we shouldn't ask for support.
- When issues or needs remain only in your thoughts there is no hope for anything to change.
- Be aware of the tendency to diminish your importance to those who really care about you because you are concerned about being a bother to them.
- Being an imposition is a two-way street because anyone who feels imposed upon either hasn't considered the impact on themselves or feels differently about whether or not the request is mutually beneficial.
- If you are worried about being an imposition, have a conversation about your needs and concerns with the person you don't want to burden.
- Fears of rejection and being vulnerable can lead you to make choices that end in regret and isolation. The only way to conquer fear is to get out of your head and communicate or act.
- The fear of being vulnerable or exposing your inadequacies can stop you from asking for support. Remember taking on anything new requires guidance, support, and patience.
- You are a one of a kind masterpiece that can't be replicated and there is freedom in letting go so others can help you.
- The pursuit of perfection will rob you of authentic relationships and enjoying a life that you deserve.

Not wanting to be a bother, concern about being an imposition, fear of rejection or being vulnerable, the belief that nobody can do it better than you, and trying to maintain the illusion of perfection are

all barriers to asking for support. Becoming conscious of how these barriers run in the background of your mind can reduce their ability to create distress in your life.

Reflections

- Which barrier is your greatest impediment when asking for support?
 - ☐ Concern of being a bother
 - ☐ Not wanting to be an imposition
 - ☐ Fear of rejection
 - ☐ Fear of being vulnerable
 - ☐ Belief that nobody can do it better than you
 - ☐ Trying to portray a perfect persona
- What impact has that barrier had on you?
- What are 1–2 small steps you can start with to overcome the barrier you selected?

Reflections

CHAPTER 4

Become Aware of Your People Pleasing Ways

"If you just set out to be liked, you would
be prepared to compromise on anything
at any time, and you would achieve nothing."

MARGARET THATCHER

Unfortunately, most of us know at least one woman who has drained her bank account to support the lifestyle of an adult loved one or friend. Admittedly, I have to guard against the tendency to be a people pleaser. I have seen how many women who, out of love, pour out all they've got, give all they have for the sake of their adult child, spouse, partner, or job, and suffer because they didn't think about themselves. We also know the woman who does everything around the house: cook, clean, manage, work, coordinate, entertain, plan, and pay for the sake of being referred to as the good mom, wife, partner, or friend. Everyone else in the house seems to have ample time to relax while she runs herself ragged. They are people pleasers.

People pleasers often fall into the trap of being taken advantage of by others. When you attempt to decrease people pleasing behaviors and wrestle with the guilt of not meeting their needs, you may find that the recipients of your efforts will complain about how you are depriving them. They were more concerned about getting their needs met than they were about you.

People pleasers are individuals who have an overwhelming need to

please and care for others because of their desire for love, acceptance, affirmation, or validation of their existence. People pleasing can evolve as a behavior because you were rewarded with positive reinforcement when you did something nice for others. It can also evolve from: Fear of Rejection – the continual need to do everything possible to make another person happy so they won't leave or stop caring for them. Or, Fear of Failure – that you don't want to make a mistake because it will disappoint others, create some negative consequences so you focus your efforts focus on getting things right.

Don't get me wrong, I believe in giving, putting my family and others first, serving and helping others in need. However, when we permit a work situation, another able-bodied adult, or our child that is eighteen or older to put us in a place that compromises or diminishes our security, energy, health, safety, financial stability, or self-esteem, I say stop the madness and look at the cost to your life.

We cannot let ourselves become victims of circumstances due to deceiving ourselves with emotional attachments, denial, or ignorance about how we are permitting ourselves to be taken advantage of.

There may be the employer that you feel you can't draw boundaries with who calls or makes requests that impact your weekends or evenings. We are in an on-demand culture that expects immediate responses. Depending on the work you do, it sometimes requires that type of response, however, that should not always be the case. People pleasers will condition themselves to just respond and not create boundaries where appropriate.

I did work for a consulting firm that often made last minute requests. One time, as Easter Weekend approached, I was asked to do a project on a Friday for the following Monday over Easter weekend. While working on the project my toddler was in a nearby room playing. When I came to check on her, I saw she had thrown up on her dress and first thought she may have had a stomach virus. I thought I had everything out of reach and realized she had found a balloon that she swallowed. Thankfully, by God's grace, she had thrown it up. I compromised my child's safety to crank out some work on a holiday Sunday to please my employer. It was a lesson that taught me about boundaries and making choices that honor what's best for my household. My decision was born

out of monetary gain. I did not consider that it was an unreasonable timeframe and compromised the safety of my child.

Then there are those emotionally manipulative and or abusive people in your life who, at every turn, find the wrong in everything you do. They tear you down through negative or unappreciative comments or talk about how or what you should be that you aren't.

In all the scenarios, when we operate in the people pleasing mode, we can become the self-appointed victim. We feel like we need to support the way we are being treated so that we can feel appreciated, liked, or loved – no matter how much it hurts. No matter the scenario, there is often unexpressed frustration or resentment that just eats away at you while the perpetrators carry on with their lives. We resent the person or entity for situations that we have the power to change.

Shifting Away from People Pleasing Ways

People pleasing is a deeply engrained behavior, so much so, that it takes continued effort and time to change it. As you begin to shift away from people pleasing, it will mean developing an awareness that you're responding to others needs based on their feelings and desires. If you feel anger, resentment, frustration, or unhappiness while wanting to fulfill someone else's needs, it is likely because you are engaging in people pleasing.

There are actions you can take as you work on shifting away from people pleasing:

1. Give yourself the Check Yourself Test.

Recognize you have a choice by checking yourself. This is when you assess a situation you are in that has negative emotions attached to figure out your role in contributing to your frustration or resentment. In a Check Yourself Test, you ask yourself:

- Are there other choices that would better suit me and others in this situation?
- What is my motivation for choosing a particular way to respond?
- Is there something I need to stop doing or request on my behalf?

- How are my choices related to that person or entity impacting my life?

When assessing your role in the situation, it also requires not putting yourself on a guilt trip for not continuing something that ultimately makes you miserable because of the negative impact on you.

2. Say no with confidence.

When you are concerned with how someone will respond to you telling them "no," it can cause you to say "no" in a reluctant manner. To say "no" with confidence means not allowing yourself to do things that can be detrimental to your well-being, safety, finances, personal needs, or quality of life. It requires putting on your big-girl panties, taking a stand, and sometimes saying "no" in a manner that makes you comfortable. Here are some examples of how you can express your desire to put yourself first:

- No, that's not in the best interest of my health, sanity, finances, marriage, children, our relationship, or friendship.
- No, that compromises my values.
- No, I am not going to support habits or lifestyle choices that hurt you or I don't agree with.
- No, I am not comfortable doing that.
- No, I am not going to do all the work while you sit by and watch. That's not reasonable.
- I would really like to help, however, I can't at this time.

How about just, "no." If you don't like to say "no" use some of the examples without the word "no." There are many ways to say "no" in a respectful and kind way so you aren't the victim of your own People Pleasing ways.

3. Know your own priorities.

What's most important to you now? What are your priorities today, this week, or this year. The clearer you are about what you need to focus on, the easier it will be to gracefully say no to requests.

4. Set boundaries.

Setting boundaries can be related to time limits. For instance, someone asks for your help and you let them know you can only dedicate one hour to help them. You might need to set boundaries with how frequently you respond to emails, texts, or other communication. Set aside a block of time to get things done and for ending tasks and work. For example, I have to create a dedicated time to stop working so I don't fall asleep at my desk. Similar to setting boundaries around time and work, also consider the same for lending money. Lend only what you can afford to give away.

5. Show empathy.

Share that you understand their predicament and then share what your compromise is or why you can't assist them.

Red Flags for People Pleasing Tendencies

There are tendencies that can serve as red flags to show you that a different response is needed to shift you away from your people pleasing ways. Tendencies to be aware of are:

- Keeping others happy so you go along with what they want even if they are treating you poorly
- Doing what others want versus doing what you genuinely want to do
- Responding to others wants out of fear of negative consequences for your relationship
- Acting to get approval or acknowledgement
- Feeling guilty when you don't respond to others
- Compromising your values to please others

Please remember transforming people pleasing habits will require patience with yourself as you work on considering yourself more and embracing a new approach to your behavior. When you push back on others behavior or requests, initially they won't like it. In time, they'll get used to you considering yourself and the impact of your choices.

Reflections

- What people or situations tend to trigger your people pleasing tendencies?
- What do you get from people pleasing that feeds your identity? For instance, when you're the people pleaser you become the reliable one or go-to person.
- Which of the 5 actions will you start using to shift your people pleasing tendencies?
 1. Recognize you have a choice and do the Check Yourself Test
 2. Say "no" with confidence
 3. Know your own priorities
 4. Set boundaries
 5. Show empathy
- Check Yourself Test: Is there something you need to stop doing or request on your behalf?

Reflections

<div align="center">

CHAPTER 5

"No" is an EQUALIZER

</div>

<div align="center">

"I have stood on a mountain of no's for one yes."

B. SMITH

</div>

The word "no" has an enormous amount of power. It can cause us to shy away from situations because we fear that dreaded word.

"No" Has Muscle Memory

The word "no" has a long-standing impression in our memory with its association to negative experiences. It is a word that's engrained into our consciousness early in life, when we are old enough to crawl. Our parents or caregivers said, "No don't touch, do, or say that." As a child or adolescent, we might have experienced "no" by not being invited to something. It may have been the "no" you experienced at work or school. The relationship that suddenly ended when the other person stopped calling or coming around was interpreted as a definite "no" in your mind. Our association with "no" is not a fond one. It's no surprise that we would try to avoid the word "no" when someone:

- Implies "no" and says, "we will consider your feedback"
- Indirectly says, "no, I am not interested"
- Serves "no" straight up, "No, no and no"

Despite the unconscious aversion we have to the word "no," we have to transform our relationship with the word so that it doesn't get in the way of seeking and receiving the support we need. It is important for us to recognize that the power of that little word is directly related to

the meaning we give it. We have the choice to give the word "no" new meaning when anticipating it as a response to a request.

"No" is an Equalizer

I often say "no" is an equalizer because it leaves you wherever you were before it was ever stated. When you ask for help and the response is "no," you haven't lost or gained anything. You are still in the exact place you were before you ever asked the question, making the "no" an equalizer.

Here's the interesting thing, more often than you expect, you'll get a "yes," a modified version of your request, or a recommendation for another source so you end up being in a better place than before you made your request. In the face of a "no," you can ask other people for assistance or keep going back to the original person of your request. At times, you might need to learn what the other person needs to support your request.

I am reminded of when my daughter asked me if she could get a pet. I said, "no." I told her to continue her quest if it was important to her because one day my "no" might turn into a "maybe" or "yes." Well, that "yes" came five years later when I felt she was ready for the responsibility. It is important to increase your comfort in moving forward even when you anticipate that there is a high likelihood of a "no." When faced with any new behavior, what's required is practice, patience with ourselves, and persistence to develop proficiency. Here are some personal examples of when a "no" turned into a "yes.":

- I asked for the comments on a performance evaluation to be changed because they were inaccurate
- I requested a commuting assignment which required I fly to my work destination on Monday and return home on Friday for a year
- I went back to clients to renegotiate a fee
- I asked for someone to communicate in a way that was less offensive
- I requested food be prepared in a way not on the menu to suit

my taste or dietary needs at a restaurant
- I often ask for an additional discount for a purchase at a store, even when shopping at major retailers

For each of the examples, it required me to express my rationale and why it would be of benefit to the source of my request. No matter the nature of your request – whether it is asking to be treated a certain way, or for something to be changed, or for something you want – it takes courage to proceed forward when you are faced with the possibility of a "no."

Unconscious Automatic "No"

Another way we're affected by a "no" is when we we're the ones saying it in response to support that's offered. These are often instances when we say "no" without thinking about it. I have discovered I have an automatic "no" trigger around anything that threatens my self-sufficiency. For instance, I was taught growing up that as a woman it was important to be self-sufficient, which translated into I should always have money to care for myself. My great grandmother who was a freed slave, embraced the notion that women had to be able to make it on their own and ensure they had their own financial resources. This notion was taught to my grandmother and her sisters, my mother, and eventually it was passed down to me. I have had numerous instances when I unconsciously refused support, saying "no" to it because of what I learned from the women in my family. The more we know about how our behaviors can cross generations, the better we can support ourselves when needed.

My unconscious beliefs caused me to automatically say "no" to offers of financial help even if I needed it or it was being offered out of love. I said "no" to my mom who offered to help with the down payment for the first home I bought. I rejected my husband when he suggested I stop working which made me feel guilty that I wouldn't be contributing to our household at the level I was accustomed to. I thought he must be crazy to make that suggestion. And I thought that I always had to earn money to pay for my wants and needs. I have

experienced internal resistance when a friend wanted to pay for a meal when we were out eating and had to accept that they wanted to do something for me. After getting married, I was against selling my home for two years because I wanted to have a safety net. When it came to finances, I had to look at my automatic "no" around finances and begin practicing how to be more open to receiving. I have come a long way and today I am much better at accepting gifts and support.

It is important to learn what your automatic triggers are that drive you to say "no" without consideration. Is your automatic "no" to avoid change, keep people away, to maintain control, or because of what you often heard in your home growing up?

It will take boldness, persistence, and initially small steps to transform your relationship with "no." The key is not to let a lifetime of experiences associated with the word get in the way of you obtaining the support you need, getting your needs met, or accepting kindness from others.

Reflections

- How does your perception of being told "no" impact you making requests of others?
- What are safe areas for you to practice making requests that typically result in a "no?" For example, I initially started practicing making special requests at restaurants.
- What are some instances where you respond with an automatic "no?"
- What is in your past that causes your automatic "no?"

Reflections

CHAPTER 6

Make the Most of What Is Most Important Now

"Since everybody is an individual, nobody can be you. You are unique. No one can tell you how to use your time. It is yours. Your life is your own. You mold it. You make it."

ELEANOR ROOSEVELT

Throughout our lives we are exposed to images that shape our perceptions about how life should be. These images come from our families, community, media (e.g. movies, favorite shows, advertisements, songs we listen to), social media, and what we read. It's the same for the people we identify with as being successful, whether that person is a friend, businessperson, movie star, public figure, or athlete, etc. They, too, influence how we view life.

Live in the Here and Now Versus in the Should've and Could've

At various points in my life, I have let society, the organization I worked for, family, friends, or a storybook fantasy dictate how I made decisions. I did not have an intentional focus on what was important to me during particular seasons of my life.

"Should" is an interesting word that is related to expectations, plans, or intentions. Let's face it, our expectations, plans, and intentions don't always unfold in the way we want. Sometimes it's because we aren't prepared, haven't done our part, or it is not where we are supposed to be at that time in our lives. I have also come to realize that there are times

we want to have a certain type of experience and we get what we hoped for. For instance, I wanted to experience what would it be like to not have to work and primarily rely on my spouse to provide for our household. I got what I hoped, however it wasn't how I would have dreamed it to be. The real question becomes, is the "should" in your life what others, media, social media, and advertisers are telling you is important or is it what touches your heart, gives you energy, or inspires you to action?

I have often been my own worst critic, at times, being impatient with myself for not accomplishing something when I thought I should, whether it was not moving forward with my career more aggressively, lamenting over a slow season with my business, or something else.

It was between the years 2009 and 2010. I was in the first year of being remarried and had moved to a new home. This was after the financial market drop and the US entered a deep recession. Business was horrible because privately held companies and government entities were being conservative, minimally spending money on "soft skills" to develop their people. Here I am in this new marriage and we have unexpected bills due to a water main break that was causing a sewage back up into our house, my teeth needed some very expensive work, and my youngest daughter was in her last year of elementary school which was a year of lots of costly activities. I was very distressed from our financial pressures and lack of steady work, aside from serving as an adjunct professor. Thankfully, we had my husband's military retirement and stock options from my former employer which I cashed in at an excruciatingly low price.

During that year, I was able to attend all the school trips, lead fundraising efforts for the school, and be present in my precious daughter's close-out year of elementary school. At the end of that school year, she told me how much she appreciated having me around. I didn't recognize until later that my financial and employment circumstances had given me an opportunity to be more present in her life and experience a glimpse of being a stay-at-home Mom. This was, in fact, how I wanted to be in her life during those impressionable transition years.

I could have made the most of that slow business season focusing on what was a priority at the time, my family. Better that than lamenting over what should have been. Now I can look back and be thankful for the

time I had, the experiences we shared attending school presentations and trips, cooking lunch for school fundraisers, and being with my daughter after school.

Living in the here and now means abandoning being unforgiving, critical, and harsh with yourself when things don't turn out as you think they should.

I have come to realize that at different times of our lives we have different priorities. In order to truly support ourselves, it means first recognizing what is most important to you at that time in your life. Once you have determined what is most important, it then requires giving yourself permission, encouragement, and the space, platform, resources or whatever it takes to focus on that priority without regrets. With this mindset, "I could've/would've /should've" is given minimal attention. Identifying your priorities, however, does not mean that you are singularly focused. It means that you make time for your priority and plan around it. So yes, you can have more than one priority.

Focus First on What Matters Most

I left a very lucrative career after twenty years as an associate director at Procter & Gamble. I loved my career there. I was a single mother with a one-year-old daughter. I left to start my own consulting business. Many people thought I had lost my mind. I had three main priorities at the time. The first was doing work I loved in the DMV (Washington, DC, Maryland and Virginia) close to home versus traveling 70-80% of the time. The second was to be present during my daughter's life during her formative years. The third was to maintain a community of friends and family available to lend support which is critical for any mother, not to mention a single mother. Many of my decisions about the consulting work I accepted depended upon on where the work was located and if or how long it would require me to be away.

When I function from a place of making life decisions around what's most important, I am at peace, gratified, and a whole lot easier to be around. On the other hand, when I do not, I am resentful, unsettled, and question if I am living up to my purpose in life. When I stay true to what is most important, I also have a much greater capacity to generously give of myself to others because I am giving from a place

of fullness versus a place of depletion. When we are not clear about our priorities, not invested in what we are doing, it drains us and it becomes more difficult to give to others.

There are times we will focus on our career which requires stellar performance, developing a professional persona, and being open to new people and experiences. There are also times when you just want to maintain your current job so you can focus on personal areas such as relationships, parenting, community involvement, spirituality, or travel. Don't get it twisted, even if you are focused on priorities outside of work, you still need to perform at work at a high level.

If there is a life demanding situation like caring for an ill family member, financial collapse, or a personal health concern that distracts you from your work, it may require a courageous conversation with your employer about where you need to focus your energy during that period. Depending on the organization, accommodations can be made that will offer you the freedom to do what matters most at that time.

When we focus first on what matters most to us, we can increase our energy and capacity to focus on other areas that we aren't as passionate about and expand our ability to give to others. The key is being able to define what's most important during this current season of life and fully walk in it. To make the most of the here and now, try to resist looking at your world through the lenses of "could've/would've/should've," and consider what matters most.

Reflections – Make the Most of What's Most Important Now

- What's most important to you right now? Are you giving too much attention to what others say it should be?
- Is there a should've/would've/could've in your life that's impacting what's most important to you?
- What support do you need to embrace what's most important now?

Reflections

CHAPTER 7

Hardwired to Give and Not Receive

*"It's that wonderful old-fashioned idea
that others come first, and you come second. This was the
whole ethic by which I was
brought up. Others matter more than you do,
so 'don't fuss, dear; get on with it."*

AUDREY HEPBURN

Delores is one of those people who is always there for others. She gives and gives and gives yet she is often hard-pressed to let others know that she has any needs. Delores is a highly competent and successful businesswoman who ran into financial hardship following the passing of her husband. Her business declined following reverberations after the 2009 recession. She also found herself needing to help family members in financial crisis. She had a former career in the financial industry which made her situation all the more crushing because in her mind she should not have been in the state of financial hardship. She kept her dreadful circumstances to herself finding foodbanks for food, going into arears with bills, and suffering in private disgrace to the point of having to file for bankruptcy. Only after she had filed and was on the road to recovery did anyone close to her learn about her ordeal.

Given how she showed up for others, people in her orbit who could relate to her situation would have offered support.

Hardwired to Give and Not Receive

Many of us have been raised to think of others first, do for others, and

not for ourselves. This quality is quite admirable. Doing for others can be extremely gratifying, a source of fulfilment, and cause us to feel useful or important. The challenge is when we put others first and ignore, discount, or even reject our own needs.

When we go about our daily lives without taking ourselves into consideration, it requires constant adjustment away from our actual needs. There are contributing influences for why we become hardwired to give and not receive. Some of these contributors are upbringing and cultural history and what we receive from the media. One of my majors in college was sociology, the study of the development, structure, and functioning of human society. When we use the term socialization, it's often in reference to children, but socialization is an ongoing process of adaptation to other individuals or groups, roles, and situations. Sources of socialization include family, mass media, peer groups, schools and organizations. They are how we learn to behave in a manner that is approved or valued socially. They influence our beliefs and actions as children and adults.

Upbringing

Past experiences affect human behavior. As a child grows up, what they are exposed to in their family, their early experiences affect their actions, behaviors, and perceptions of what is acceptable and unacceptable behavior.

I saw my mother, grandmother, and other women doing things for our immediate and extended family like cook, clean, encourage, entertain, handle household projects in addition to working and obtaining additional educational degrees. As kids we were always doing something or going somewhere. The women in my family held professional roles and poured themselves into their jobs. I was also told about great aunts who ran boarding houses, cleaned homes and businesses yet used their time and money after work to help others. I remember seeing my mom in the kitchen late at night with books spread out on a table, writing papers so she could get a master's degree and further herself professionally as a single mom. The women that surrounded me growing up were active in church committees, taught Sunday school. They contributed to the community by volunteering wherever the need existed. I watched adult

women take on the world seemingly alone. They were always giving their time and energy to others. It is no wonder I grew up to emulate those same behaviors. Now, I see the same traits in my baby girl.

Imagery

The media is another source that contributes to our perceptions of how we should behave. I remember seeing images in movies and sitcoms of what I call "superwomen" who looked fabulous and fit, masterfully juggling, and keeping their spouse happy, raising a perfect family, working and contributing to the greater good of the world around them with ease, a scenario that could only be created from a script, staging, and camera lens. These are some of the messages that were either implied or communicated directly:

- As women we must sacrifice for the sake of others
- Put others first
- Be responsible and make sure you handle your business at home, for your family and job
- Never let them see you sweat at work
- Figure it out on your own
- Don't let others get the best of you
- It's easier to do it yourself if you want it done right
- Push through, hold your head high, and maintain your composure when things get rough even if you are emotionally or physically hurt or you are abused or disrespected in some way
- Work harder, do your best, and know that you'll have to prove your worth as a black woman even if you are better

As I reflect upon growing up, I never saw women being waited on, served dinner, and or kicking back relaxing. The women were always preparing, doing, fixing, and cleaning things for the home. They often did these things with other women and there was a level of fun to the process, but it was still around the household work. The image of slowing down for a luxurious relaxing bath was only in the movies.

Centuries of Giving and Not Receiving

Women across cultures around the world are often socialized to handle things and quietly accept inequities or injustices. While we live in an era where women are speaking out for their rights, respect and equality more than ever, old behaviors still exist. In America, dating back centuries to early 1600s, from the days of slavery, black women had to give to others with the expectation of not receiving anything. It was normal to work hard, give to, and take care of others. They had to figure out how to survive desperate circumstances all while discounting their very own struggles, emotions, needs, and dignity. For many African American women, the concept of doing for everyone else at their own expense has been a part of their DNA and life experience. Why women tend to be givers and doers is not isolated to race or country. There are many other historical examples that give insight into this unfortunate situation.

While our plight is different from that of the past, there are many women today whose beliefs reinforce a denial of personal needs for the sake of others. I am not saying that these aren't admirable qualities or that I don't demonstrate some of these behaviors myself. However, to live and function without putting yourself into the equation is a recipe for stress, burnout, resentment, and an unfulfilling existence.

Open Yourself Up to Receive

As we examine how we are hardwired to behave in a certain way, we can choose to do some rewiring to create a reality that includes doing for others and beginning to open ourselves up to receiving support as well. Be aware that givers look for ways to give to and help others. Givers are often uncomfortable with and resist receiving from others. To begin being more receptive to receiving from others:

1. Accept that you are enough and deserve to receive without giving anything
2. Become more open to receiving compliments, acts of kindness, acknowledgement, and gifts
3. Be aware that there is an imbalance if you primarily give. Learn to create a healthy balance between giving and receiving

4. Recognize that you deprive others from the joy of giving when you resist receiving

Reflections

- Do you tend to give to others while neglecting your needs?
- If yes, when and how do you tend to discount your needs?
- How can you begin to become more open to receiving from others?

Reflections

CHAPTER 8

Advocating for Yourself

*"If you want what you're saying heard,
then take your time and say it so that
the listener will actually hear it. You might
save somebody's life. Your own, first."*

MAYA ANGELO

While I was in the hospital several years ago there were medications I was offered that were routinely administered to prevent pneumonia, flu, blood clotting. I declined them because it didn't make sense given my body was already fighting an unknown virus that was affecting me. A nurse several times encouraged me to take the flu and pneumonia shots. When my friend Irene who was in the pharma industry overheard the nurse advising me to accept the shot, she gave me the "don't do it girl" look. Once the nurse left, she told me the shots were standard protocol.

Her brief education about standard medical practices gave me something to consider. The next time the nurse came in as I lay in my weakened state and asked to administer the shots, I said, "I am here because I have been diagnosed with a serious virus that my body's been fighting for weeks with high temperatures and my kidneys are not correctly performing. It doesn't make sense to introduce new antibodies into my body when it's fighting some unknown virus." Then I asked her if she would take it if she were in my condition and she very frankly said "no." It dawned on me that I was speaking up on my own behalf for what I believed was right in spite of the other

person having the expertise. I wondered how often we go along with what someone tells them just because they are the perceived expert or person in authority.

Don't get me wrong, I am not recommending that you become rebellious and always counter what others say. However, if you have the facts that are contrary to what someone says or you just know in your heart that something is wrong, you should stand up for what you believe. It is necessary to assert yourself even when you are frightened.

Another example of advocating for myself was when I had a commuting assignment which meant working during the week in Ohio while living in Maryland where I went to graduate school on the weekends. I had a performance discussion with the two managers whom I had a dual reporting relationship with. They expressed concern that I wasn't focused on my work while studying for my master's degree. At first, I wanted to blow up, but that would not have gone well and would have adversely affected the environment for later addressing my disagreement with their concern. Instead, I scheduled another meeting and shared my accomplishments which exceeded the written expectations. I reminded them that I arrived to work before they did and left after them. I then mentioned additional corporate projects I was involved in and shared that because I was living in Cincinnati during the week and returning to Maryland on the weekends, my life only consisted of working very long days and studying for school in the evenings. I requested that they amend my performance evaluation because of the facts I presented, and they did.

I could have grumbled about how unfair their assessment was or respectfully voice the error of their assessment. I chose the latter. When standing up for yourself, it is not only important what you say but how you say it. It must be communicated in a manner that the other party can receive and that makes them feel valued in the space of a conflict or disagreement.

You may be faced with having to stand up for yourself and advocate for a position that you may be the best candidate for. You may be in a relationship where someone is not treating you in a manner in which you feel respected or fulfilling your desires and you need to help them learn how to treat you. You may have to validate your contribution to

a program, project, or effort that you aren't being acknowledged for. Or you may have to make a request for something as small as receiving a discount. The point is that you need to stand up for yourself, girl, because you have to be an advocate for yourself.

Acknowledging our own contributions or sharing what we have done, especially in the workplace, is another area where we do not often stand up on our own behalf. I have heard women talk about not being acknowledged for something positive they've done in the workplace. You can't assume that your supervisor or manager knows what your contributions have been. Women are more apt to focus on performance presuming that those evaluating them are aware of their contributions. For women of color, particularly, rarely are we taught to speak glowingly about our accomplishments or contributions in the workplace. But, by not sharing your accomplishments with others, how else will someone know what you've done unless you tell them?

We need to recognize that supporting of ourselves is advocating on our own behalf and removing the expectation that others will do it for us.

Reflections

- Are you comfortable advocating for yourself?
- If yes, when are you most comfortable?
- What area of your life do you need to advocate for yourself more?

Reflections

CHAPTER 9

Don't Let the Boogie Man Stop You

"Worry is a cycle of inefficient thoughts
whirling around a center of fear."

CORRIE TEN BOOM

remember being afraid of the boogie man when I was a little girl. The boogie man was an imaginary character with supernatural powers that would come to get you and do horrible things to you at night in the dark once your parents left you to go to sleep. The boogie man dates back to the late 1890s – terrifying children for over a century. Some might say that the boogie man is an imaginary character that only children fear. As adults, though, we can also create imaginary thoughts in the dark crevices of our minds that paralyze us with fear or deter us from progressing in our lives. This is the adult version of the boogie man.

It's not unusual for us to create scenarios in our minds of what may happen if we do something in support of ourselves. Our adult boogie man can conjure up negative past experiences or fears that haunt us when we're presented with a new situation. This is why the adult boogie man has more power than the juvenile version. It can stop you from pursuing what you want out of fear of the unknown or the misperception that you aren't good enough.

I recently received text from Lynn, a young woman I had previously coached, asking if we could talk for a few minutes. I knew it had to be urgent. When we talked, she described a situation where the woman who had sponsored her to come into a new organization and who was

her manager had abruptly left. Lynn felt disconnected, isolated, and she feared her future with the company was coming to a grinding halt after four months as a new employee. She didn't know her former manager's boss and asked me if she should start looking for a new job at another company? She feared that the negative reputation of her supervisor who was now gone might attach itself to her, so she was invariably doomed. My response to her was to not let the boogie man stop you. I pointed out that she had created this horrible scenario and was ready to jump ship without a lifeboat a.k.a. other job prospects. We discussed her fears and Lynn realized that they were made up in her mind. We instead talked about what her concerns were and what needed to be addressed to create a foundation for her future success. I'm happy to say that she remained gainfully employed with the same company.

The boogie man can stop us from having conversations that can bring clarity to a situation. The boogie man can stop us from asking for help for fear of rejection. The boogie man can cause us to doubt our ability to do something or be open to embracing a new relationship.

Laura is attractive, thoughtful, devoted to family, and very giving. She is a high school graduate with a good government job. While traveling, she met a man with a great personality, who was chivalrous, smart, and handsome. He had a master's degree and lucrative business. They talked regularly and began dating. He was quite interested in pursuing a relationship with her. He adored her, was willing to be flexible and wait her out while she worked through her insecurities about being in a committed relationship with him. She viewed him as well-educated and successful while she viewed herself as ordinary and not good enough for him. She couldn't figure out for the life of her why he wanted to be with her. She feared if she got in a committed relationship with him that he would eventually leave her because she wasn't as smart, successful, or a spiritual as he was. She had been hurt before and was not up to risking her heart being crushed again. After a couple of years of an on-and-off relationship, he moved on and married someone else. The boogie man was her fear of inadequacy and unworthiness. It kept Laura from opening up to what might have been the relationship of her dreams. She is still single and unattached. The

fears based on past experiences took on a life of their own and kept her from having what she said she really wanted.

Areas Where the Boogie Man Can Stop You:

- Inquiring about a job opportunity
- Pursuing your dream
- Writing a book
- Being open to a relationship
- Having a candid conversation
- Expressing what you need to make it through a difficult time
- Saying what you want
- Saying "no" to a request
- Requesting support to take on a goal
- Assuming new responsibility or accountability
- Asking for help so you don't have to take the weight of something on your own
- Taking an unpopular stance for something that's important to you
- Doing something because of what people will think or say
- Taking a calculated risk

Remember that the Boogie Man is imaginary. However, depending on how much we entertain him, he can truly seem real. Step back and look at your fear to determine if it is:

1. Founded on a past experience that you are concerned will repeat itself
2. Based on an overactive imagination versus facts or evidence that supports your concerns
3. Related to tangible information that supports your fears and apprehensions

If your concerns are truly based in reality, consider if you're up to

handling the risk of what might happen because, frankly, sometimes taking action is definitely worth the risk. Only you can answer that question. Do not let yourself be stopped because of past fears or your imagination also known as the boogie man. When you are in support of yourself, you stop the boogie man from taking control of your life.

Reflections

- What is your boogie man?
- How does your boogie man stop you from moving forward in your life?
- What positive self-talk can you use to replace the boogie man chatter in your head?

Reflections

CHAPTER 10

You Are Not an Island

"Knowing that you're not alone really does
make all the difference in the world."

NORMANI HAMILTON

One of the ways we women become anxious, overwhelmed, and disheartened is because we take on our world alone as if there is nobody willing or able to assist us. I know firsthand about putting on the cape of the superwoman façade, running to everyone's rescue. I proudly said "no I've got it handled" whenever anyone offered assistance. Meanwhile, I'm crumbling inside saying:

- How the heck can I do all that is on my plate?
- What did I get myself into?
- I knew I was taking on more than I could handle.
- I should be able to do this.

I spent twenty-five plus years of my adult life believing I had to do things on my own. At a very young age, I watched my mother handle so much on her own. I didn't want to be a bother and thought that's just what women do. My mother was dealing with having recently moved due to separating from my father and attending to my ten-year-old brother who had just had open heart surgery. There were some adults who told me, a seven-year old, not to be a bother because Mom was caring for a very sick son, working, and handling many other life crises. Given my very independent nature, doing things on my own

made sense to me. The examples in my home, family, and community validated my perceptions that women were supposed to be handlers taking on everything alone.

Handling Life Alone at a Young Age

Acting like I could handle things on my own produced some good results. It also produced some life-altering negative results. There were times when I needed someone to intervene but didn't reach out for assistance because I thought I had to handle the situation on my own. I was fifteen years old thinking about going to college and going with friends from high school on trips to visit schools out of state, taking the New York City subways to visit New York University and Fordham Universities. At the end of what my mother thought would be my junior year of high school, I asked if she was going to my graduation. She was shocked because she soon learned that I would be graduating early due to taking on an accelerated program at school. With the earnings from my part-time job, I had paid for my college application fees and was accepted into Boston College all without my mom knowing. I was a great handler for myself at a young age. But, then there was one of many bad examples of handling a life situation alone. One such situation would have an adverse impact on my life for decades to come. I know my mother would have supported me through it had she known.

I went to a party and unbeknownst to me, this guy Smitty, who I had a crush on, had left the party but told me he was coming back to get me. The truth is that he left so that a friend of his who had been checking me out could spend time with me. I waited and waited, and his friend Bubby who he had left me with, and another friend brutally raped me at gunpoint while his girlfriend helplessly pleaded with him to stop. I felt ashamed. It was as if I should have known better to hang out with people who, in this day and age, would be called thugs. I carried the emotional trauma for decades until I sought professional help due to panic attacks that started in my early thirties whenever intimacy was on the horizon. I was in my early forties when I finally told my mother. Of course, much damage had been done. The trauma was something I did not have to carry alone but I did... for decades.

My many decisions to go it alone affected me emotionally as a teen and later impacted my ability to trust and become intimate with a partner.

Handling Situations Alone Can Come at a Cost

I arrived in Baltimore the night before starting my first job out of college the next morning with Procter & Gamble. I was told by the company that I had a reservation at this reputable hotel. However, when I got there, I soon discovered that hotel hadn't held my room and now they were sold out. When describing the situation, my taxi driver kindly turned off his meter and drove me all over Baltimore to major hotels which there weren't many of back then. All the reputable hotels were full. So finally, we ended up at the North Avenue Motel that had a plexi-glass window to pay through...aka danger. The cab driver went with me to pay, walked me to the room, and stayed outside until the door was locked. He told me not to leave until morning. I sat in the middle of a bed fully clothed listening to the pimp next door threaten to kill one of his girls, watched mice and roaches freely roam through a well-lit room, and surveyed every inch of the room which had dried blood stains on the walls. Did I call my Mom, new manager, or anyone else? Of course not. I had it all handled. So much so, that the next day I was falling asleep while completing my new hire forms for my job at P & G. Prior to learning what happened, the division manager's secretary shared with me that she thought, "oh we have a real winner here." She later asked me why I hadn't used the contact number that was offered for emergencies. I had no answer because I thought that as an adult, I should have been able to handle the situation. At age twenty-one, your experiences and reasoning are still limited but I felt I was grown and had to handle things on my own.

Support Is Often Available if You Ask for It

Trust me, there have been many times in my professional and personal life that I failed to ask for someone to pitch in and share the load. I avoided asking for an explanation, information, assistance when overwhelmed or for support of someone close when I was emotionally

distraught, or scared. There are people in your life – parents, siblings, relatives, friends, and even colleagues who would be more than willing to help if you articulate your needs. It requires stepping out of your comfort zone and sharing the details of your circumstances.

I am blessed to have a husband and daughter who want to help out most of the time. Far too often they've seen me struggle because I wouldn't slow down or take the time to figure out and express how they could help me. Now, though, more and more, I am sharing what I need and finding that most of the time there is someone who is willing to support me.

Asking someone to lend a helping hand when you're accustomed to doing things all by yourself can be uncomfortable or feel like an imposition. It requires a continued deprogramming to change the perception that you can't ask for help. If people can't help out or come to your aid, most of the time they'll tell you. True, someone may not be as organized, cook as well, or perform tasks as you would. If you expect them to emulate you, then that's possibly the old perfectionist bug that's inside of you coming out. It's an idiosyncrasy you'll have to examine and address.

It takes a lot to maintain the appearance of being a "superwoman." You need to look flawless and fabulous. It requires finding ways to maintain your energy with caffeine or resort to other methods to artificially sustain a high energy level which may toll on your health. Worst of all, it requires that you pretend to be something you are not and never can be.

It is essential that we begin to look at what causes us to act as if we have to take on the world alone. Is there any truth in our belief that we are the only one who can do something?

When it comes to the routine tasks such as errands, shopping, washing, cleaning, purging, organizing, cooking, you can let someone help with a project or tasks. You can allow family and friends to help out, who in the past, have expressed a willingness to assist you. There are people in your life who will help you.

There are times when not being an island means seeking professional help in the form of counseling. I recall in my early thirties the emotional sense of feeling like I was headed over a cliff. I was struggling about the

viability of my first marriage, at a crossroads about the direction of my career following the path others envisioned for me versus where my heart was leading me. I was miserable. I felt like I was going to break so I called the Employee Assistance Line (EAP) to find a counselor to help me sort out all I was feeling. It was enormously helpful. There can be a stigma associated with counseling, however, when you feel helpless or all alone in dealing with life's inevitable challenges, sometimes you just need an unbiased point of view to help figure out your situation.

I would be remiss if I didn't address that there are times when people offer to help in our personal and professional lives then complain or go missing in action when we do reach out for help. Yes, there will be those who will espouse empty promises for assistance. If they live under the same roof, with a wrapping of appreciation, remind them of their offer and your need. There will be those who you realize need to come off your list for support because their actions have repeatedly demonstrated they are just talk. Then there are the select few who are more than happy to occasionally pitch in to help you as long as you don't abuse their kindness. Through trial and error, you will learn who is in your corner to help when needed.

When we act as if we have to handle everything in all areas of our lives on our own, we deplete our energy, joy, and enthusiasm for life, and limit what we can learn or accomplish. By being an island unto ourselves, we invariably bring unnecessary challenges upon ourselves. We can avoid these challenges by removing the objections we create for why we feel we must do things on our own such as "we do it best" or "no one can do it as well as me." The key is to recognize that whatever you are up to in life does not have to be done alone and there are people in your life who will come to your aid when needed!

Reflections

- In what ways do you function as if you are an island with no help available?
- Who is at least one person you can rely on personally and professionally if you need help?
- What have they done and said that lets you know you can rely on them?

Reflections

CHAPTER 11

Say Yes to Angel Offers

"You can't do it all yourself.
Don't be afraid to rely on others
to help you accomplish your goals."

OPRAH WINFREY

When I use the term "angel," I'm not referring to a guardian spirit or celestial being. For me, an angel is an extraordinarily kind person who comes into our lives or rise to an occasion to demonstrate acts of kindness in times of need. Be aware that when you continually offer support to others, people will observe your behavior. Your generosity can create an environment that encourages others to help when you need help. They may see you hurting and suffering during a crisis or loss and offer their support. When the offer is made, it's up to you to accept and say yes.

Sylvia's husband was critically ill. He was in a facility under full-time care and unable to walk. He wanted to spend his last days at home. Sylvia is one of those women who does everything for everyone else and never missed a beat when someone else was in need, be it a family member, friend, colleague, board member, or stranger. The loving and dedicated wife that she was, she had no second thoughts about bringing her husband home although she had little support from insurance for home health care and limited support from her children who were grown and gone.

Sylvia had friends, who upon learning what she was about to do, jumped into action. They anticipated what she would need for the

herculean feat she was embracing until services and resources were in place. Her friends, family – some of who were even estranged – and coworkers provided supplies and food. She was struck by the loving generosity of those who came through for her. Initially, Sylvia was humbled, in tears as she wanted to refuse the help because she was only used to doing for others. Had some of her angel offers not been thrust upon her, she would have struggled unnecessarily in an already dire situation of supporting the love of her life as he transitioned to the end of his life.

I have also experienced the blessing of angel offers. My girlfriend Izetta offered to have my daughter for over a week when I went on my honeymoon. She and her children served as a surrogate family to support me when needed and also provided my daughter a needed escape from my supervision.

Several years ago, I was in the hospital close to the time when I hold an annual event in my home where more than sixty friends and family visit for a pre-Thanksgiving dinner. I have hosted this dinner for decades. Most of my friends thought I would cancel because I had been home from the hospital only a week still recovering. The trooper that I am, I still had the event and friends wanted to know how they could help.

Quite frankly, I didn't know all that I needed but said yes to all who offered help. Ms. Mary, a dear friend of my deceased Mom, took on most of the cooking that normally I would've done. Others helped with shopping. My then fifteen-year-old daughter cooked, baked, cleaned, put out the food and helped to keep the food refilled. I wasn't allowed in the kitchen during the event and was told not to do anything but sit down, not that I had the strength or stamina to do much else. My kitchen was spotless at the end of the event with everything cleaned and put away by several of my dear friends Cathy, Debra, Jackie, Terry, and Denise who expertly took over. They created a community with one washing, one drying, one putting things away, one throwing things away, and one putting things in the refrigerator. I was humbled and thankful for support that exceeded what I would have ever asked of my friends. As I remember their kindness and generosity, it brings tears to my eyes and touches my heart.

It's not just people you know who will show up with angel offers, strangers will as well. As a single mother, sometimes you need angels in the flesh. I did several times.

There was a woman with a sweet, generous personality who occasionally assisted the person that cleaned my home. Every time Glendal came to my home, my daughter who was one-year-old at the time would reach out to her to be held and play. She shared that if I ever needed assistance with my daughter to feel free to call her since there was an obvious connection between them. I appreciated her offer and never thought I would accept it until, unexpectedly, I had to terminate a caretaker for my daughter who wasn't working out. I called Glendal at 10 p.m. to ask if she could assist the next day due to an emergency business trip that required that I leave early in the morning. To my amazement, she said "yes, of course." Not only did she take care of my daughter, but I came home to a spotless home. She ended up lovingly taking care of my daughter for the next two years until she moved to Florida.

You may say that was an isolated an incident, but it was not. I was coordinating a women's retreat for my church at a hotel out of town and on the first night, I fell and broke the tibia bone in my right ankle. There was a host of angel offers that got me through the ordeal.

Gwen stepped up and took me to the hospital and every place else I needed to go. She even helped with coordinating the event. Patti went into high gear ensuring everything went off flawlessly. I had the help of an amazing team of women who owned it all with excellence while I watched from a wheelchair. There was Joy, Myrna, and Janice who got me home and provided support with food, getting medication, taking me to doctor visits, and offering encouragement. A classmate's mom and Thelma, a teacher from my daughters' school, picked her up and dropped her home after school.

Nancy B., one of the retreat participants who I had not previously known, was recently retired and offered her help in any way if I needed her. When people make offers like that, I have learned not to blow them off or to be suspicious that they are just trying to be nice.

As an entrepreneur and a single mom after a week I felt compelled to go back to client engagements after a week, but I couldn't drive

thirty-plus miles each way daily and feel safe. And it's against the law to drive with a cast on your right leg. I called and asked Nancy if she could help me by driving me to the client site to conduct training one day the following week. Not only did she pick me up at 6 a.m., she also dropped off my daughter at her friend's home to go to school and helped me four other times get to my client gigs. Until I said yes to the angel offer, she was a stranger.

These angel offers do not only occur during times of loss like a death in your family. While that is a time when people show up and reappear in your life to support you, unexpected angel offers are far more frequent than you may recognize.

Angel offers can be small acts of kindness and large acts of generosity like:

- Helping you when you're struggling to carry too many bags
- Paying for your meal or ticket to an event
- Helping you shovel snow or clean up leaves
- Coming to your aid, assisting to pack up or unpack from a move
- Bringing you food or medicine when you are sick
- Being a workout buddy to help you reach your goal
- Assisting to help prepare for entertaining
- Offers to babysit the kids
- Helping you drive a long distance or providing transportation
- Help with or covering a financial need
- Assisting with a project
- Teaching you how to do something you struggle with
- Organizing your home
- Praying with or for you

I once heard someone say, "when someone offers to help us or wants to extend their generosity and we refuse it, we are rejecting them and conveying that we don't value or appreciate the gift of their generosity." As a person who wants to do for others, I was struck by the idea that accepting offers is a form of appreciation. It can be a gift to the person who is offering and not only you.

When someone sees a need, recognizes you are suffering or in a

crisis, let them contribute to you by saying "yes" and "thank you." You might have to swallow your pride and permit yourself to feel humbled by someone's kindness. It won't diminish you as a person by implying you are weak. Accepting angel offers just reinforces your humanness and need for other people. Recognize there are times when others see your needs before you are aware that they exist. Bottom line: be willing to open yourself up and accept angel offers!

Reflections

- What are examples of angel offers you have rejected in the past?
- Why did you reject the offers?
- What would you need to do differently to be more receptive to angel offers?

Reflections

CHAPTER 12

Get to Know Your Limitations

"Before you agree to do anything
that might add even the smallest amount
of stress to your life, ask yourself: What is my truest
intention? Give yourself time to let a yes resound within
you. When it's right, I guarantee that your entire body will
feel it."

OPRAH WINFREY

We all have, at one point in time, agreed to do something or take on tasks that we genuinely believe we have the emotional or physical capacity or time to complete. Then we soon realize that we do not. In these scenarios, many of us maintain the "I said I would" stance and hold ourselves hostage to a commitment that wasn't thoroughly considered. One of the ways to reduce the extent to which you get caught in situations like this, that take you beyond your capacity, is to know your limitations.

Identifying your limitations means looking at unique circumstances and existing responsibilities in your life so that you can consider all that is going on and how will it affect you. You cannot always predict what will be required of you, however, without thinking things through in advance, it is likely you will take on too much.

Unique Circumstances

There are two types of unique circumstances: 1) New Life Changes and 2) Times of Emotional Stress that can cause you to take on more than

you can handle. How you consider these unique circumstances when they occur, can help you to manage the toll they may have on your life.

New Life Changes

It is important to consider how new life changes will affect you. A new committed relationship, learning something significantly new, adjusting to a new home, starting a new job, or attending college are all new experiences that will impact your life. Keep these types of changes in mind as you consider your limitations:

- A new committed relationship or marriage
- A new child in your home
- A new job
- Career change
- Going to college for degree
- Starting a program for your personal or professional development
- Building/renovating or buying a new home
- Putting on a large planned event

New circumstances can put an increased demand on your time and energy because they are a time for learning new information, skills, or new ways of behaving. It is a phase that is filled with lots of unknowns in terms of what is required for you to navigate through the time of change.

Consider, for instance, getting married. You think, well, the two of us get married and we carry on with our lives once we say "I do." Wrong! The Pastor of my church, Pastor Robbie, often says, "marriage is the collision of two lives coming together." It's making time for your spouse, their family, friends, and all the special projects you two want to take on together and integrating all that with your preexisting life.

When I got married the second time, I wanted to do all I could do to start the union off right. I added a lot more to my already packed life without asking for help. I chuckle at the thought now. However, in the beginning of my marriage, I tried to cook multiple meals every day, watch the sports programs with hubby, be attentive the to the

emotional demands my daughter who was used to having me to herself, run a business, teach at a major university graduate school program, take on new sub-consulting work, run a prison ministry program and a church capital expansion program, and advise for the local board of the Coalition of 100 Black Women. There were also all of these new things like learning to jointly manage finances, sharing space, setting up a new home, figuring out how to be intimate with a nine-year-old a door away. It was a time when I was seeing friends and family less which some understood and others didn't. I felt quite overwhelmed.

Instead of lessening my load, I grew to the point of feeling like I was going to have a meltdown. In fact, one day I did and that's when, in the midst of hyperventilating and crying, I told my family I needed their help, which they willingly gave me.

In retrospect, I see how I was trying to take on far too much and had given too little thought to my limitations. I had been warned, though. My dear friend Joy who was like my big sister said, "girl you are taking on too much, trying to be a perfect wife along with everything else you're doing and soon enough you will realize you have to let go of some things." If I had really considered the number of life changes going on at once, I would have made the choice not to be involved with so many things outside of my home that demanded my time and energy. I was spreading myself way too thin and not considering the impact that was having on myself and others.

Times of Emotional Stress

Getting married, recovering from sickness or injury, death of a loved one, recent divorce, ending a relationship, moving to a new location, losing a job, or financial challenges all cause stress.

You can also experience traumatic or negative changes that create a heavier level of emotional stress such as:

- Preparing for a wedding
- The death of a loved one
- Caring for a family member that is sick
- An accident impacting you or someone close

- Caring for a parent which requires role changes
- Regaining your sense of yourself after a divorce
- Figuring our what's next after the loss of a job
- Increased financial obligations or decreased income

When you have emotional stress in your life, you have to consider that it is more likely a time to pull back. It is a time to identify how you need to nurture yourself and establish how to move forward from your current situation. It is a time to ask for support and readily accept it if offered.

When my mom passed away, there was no way I could have anticipated all that would be required emotionally, including all the stress that came from handling her estate and dealing with the needs and requests of other family members. I was thankful that I wasn't on the schedule for classes at a local university where I taught. However, I agreed to serve as a coach while my mother was in the hospital which was not a good idea. I also agreed to continue leading a prison ministry program. It was not a time for me to lead or be accountable for anything additional beyond my home and business. Rather than consciously choosing to give myself a break, I ended up being missing in action. It took time for me to admit I didn't have the emotional capacity or energy for the additional commitments.

It is often recommended that you do not make decisions that will impact your life during times of emotional stress. Recognize that every decision you make adds to whatever is already on your plate.

Assess Existing Responsibilities

To recognize your limitations, you may need to look at all your existing responsibilities especially if you are experiencing feelings of overwhelm. At times we can be oblivious to the extent of our over-commitment. We learn to function on automatic pilot, fulfilling an unfathomable number of responsibilities and can lose sight of the toll it takes on our mind, body, and health. Considering the magnitude of existing demands can help you get a grasp of your limitations.

Most of my adult life I have prided myself on being able to juggle

many different responsibilities. I wore this quality as if it was a badge of honor. I had so many responsibilities that it felt like I was working multiple full-time jobs. I would experience occasional periods of getting burned out or sick to the extent that I had to stay in bed for several days to recover.

Going to college full time you may take four to six courses during a semester. Similarly, a full-time job typically requires that have at least four to six core areas of responsibility. At your job, imagine someone leaves and you have to take over their entire workload in addition to your own. You may be able to handle all the work for a short period of time. However, long-term there may be a negative impact on your:

- Quality of work
- Overall productivity
- Emotional state of mind that could affect your attitude
- Energy level
- Health affected from stress

It is no different when you have too many responsibilities outside of work or school. Even if your motivation is for the good of others, eventually it will adversely impact your state of mind, body, energy, and health.

For many women, there is a tendency to not consider that everything you are involved in requires time, attention, and energy to have a fulfilling committed relationship; raise a child or grandchildren if you are the primary caregiver; perform in a leadership role outside of your full-time job responsibilities (organization, committee, board member); participate an extra-curricular activity; care for a parent or family member; and maintain relationships with extended family and friends. They all take time and there is the precious, albeit very limited time, that you need for yourself. All these activities can add up to what amounts to at least one or more additional full-time jobs.

No matter who you are, if you are single, married, in a committed relationship, a parent, or full-time student, know that there are limits to how much you can reasonably take on without there being a negative impact. To begin to comprehend the extent of your responsibilities

write it all down. Create your list from these categories:

1. Full-time job*
2. Part-time job
3. Full-time college or trade school*
4. Part-time college, trade school, or professional development program
5. Marriage*
6. Committed relationship*
7. Parent or Grandparent of child(ren) living in your home*
8. Sports or activities for children in your life
9. Care for parent or family member (consider level of care required)*
10. Role in professional organizations outside of work
11. Other organizations (religious, civic, sorority, etc.), your role and level of involvement and time requirements
12. Special project or hobby that involves consistent time

Check everything you use; your devices, planner, virtual calendar, or post it notes to keep track of tasks and to make sure you haven't missed anything. Once you have captured your entire list of responsibilities, say them out loud. If you become overwhelmed or feel that your list is excessive then you know you have surpassed what is manageable. That means it is time to remove something from your list or ask for help.

As a suggested guideline to manage the number of responsibilities you take on, consider two to three primary responsibilities (see list items above marked with an asterisk) plus one to two additional responsibilities. Everyone's limit for the number of responsibilities they can handle differs. For example, your career, educational pursuits, or caring for a sick family member may be so consuming that you don't have time for anything else. The key is to assess your responsibilities so you can comfortably express your limitations when new requests arise.

Listen to Feedback about Your Capacity

As I reflect upon how I could have been more in tuned with my

limitations, I realize that I was given clues by those around me that I was doing way too much. Those of us who are consummate doers function on overdrive and often can't see the depth of our own busyness. For those in and around our lives, it is abundantly clear when we are over-extending ourselves.

I had a number of experiences that began to open my eyes to the impact that my busy lifestyle was having on me. The first was a conversation with Sister Robin, the first lady of my church who was aware of all the things I was involved in at the church. We were talking about what I was up to and I mentioned that I wanted to open myself up to getting into a relationship. She smiled and said, "You don't have time for a relationship." I was absolutely floored by her response. I retorted with, but you keep asking me to lead things and she responded with, "You keep saying yes." I can laugh at it now, but I was stunned by her remarks. It didn't stop there, though. The conversation with Sister Robin was just the start. Next, it was Gil, a close friend who is like my big brother. I've always valued his insights and opinions. He had gotten to know me quite well and said he wanted to introduce me to someone because he thought I was a great catch. However, after observing the pace of my life and everything that I was involved in, Gil rescinded his offer, saying I was too busy for a relationship.

Then, while recovering from a broken leg, my eight-year-old daughter admitted her happiness because she got to have Mommy at home and didn't have to quietly sit with books in the back of the room during my many meetings.

I was still recovering and enjoying a slower life when I met Joseph, the man who would become my future soulmate and husband. Once we were engaged, having observed the pace of my life, he requested that when we got married that I narrow my focus from four to two other leadership roles. His valid rationale was that I needed time for our new life together. He was right.

With all the clues from people in and around my life, it was still difficult to see I was taking on too much. It is quite interesting how you can feel like the world will stop if we remove ourselves from something when in reality, it'll go on without us.

Fast forward three years, after those telling experiences, my Mom

had passed and I had narrowed my focus to family, involvement in my daughter's school activities, and work. Later, when I ran into Sister Robin, I felt a twinge of guilt for having stopped serving at church all together. I shared with her that I had to disconnect and refocus. Her words of wisdom this time were consoling versus unsettling. She said, "you led and served long enough and now it's someone else's turn so you can focus on your life."

Managing Your Limitations

Once you have evaluated the impact of your unique circumstances and assessed your existing responsibilities, you will have a much better sense of your potential limitations. Knowing your limitations can be empowering because you can confidently say no to new requests and have a clear reason for your decisions. Recognize that no matter how good you are, when you over-commit, there is a high likelihood that you will do some things poorly, get burned out, jeopardize your health or emotional well-being. You may also fall short of others' expectations, creating disappointments because you haven't considered what you are capable of handling.

Make it a practice to regularly get to know your limitations, to know when you need to reach out and ask for support. It will not be easy, trust me. I know since I am still struggling with this one. However, the more you consider what your limits are and consider feedback about how much you are doing from people who care for you, the more you will be able to manage your life.

Reflections

- What new life changes or sources of stress are in your life that may require you to reassess your limitations?
- As you look at your existing responsibilities, what needs to stay or go in your life right now?
- How can you make your life more manageable?

Reflections

Pinpoint Your Needs for Support

"The journey into self-love and self-acceptance must begin with self-examination... until you take the journey of self-reflection, it is almost impossible to grow or learn in life."

IYANLA VANZANT

Another way to approach getting support for yourself is to consider where your needs exist. When you proactively take inventory of your life and do so holistically, it can reveal aspects of your life that are in need of attention. To increase your overall well-being, consider what part of your mind, body, heart, and spirit needs support. Here are some areas to think about and some questions to help you determine how you can improve your well-being.

Mind

Determine if there are areas that you need to cultivate for your growth and development. For instance, learn about a topic related to work so you can position yourself for advancement or learn concepts that will enable you to better manage your finances. I used to be a shopaholic and really didn't pay attention to my finances. At times, I hid from bills when things got out of control. So I decided to take several courses to learn how to budget, plan my spending, contribute to savings, and prepare for my family's financial future. It meant I had to enrich my mind in that area to improve. Sometimes our downfall can be attributed to our lack of knowledge about a given topic.

- What areas of your life do you need to learn more about in order to handle that area better?
- Have you considered your future hopes/dreams? What will it take for you to reach them?
- Do you need to look at the people you surround yourself with and their impact on how you view life?
- Is there a creative side of you that needs to be reawakened, explored, or nurtured?
- Can you benefit from a coach who can help you work on goals and achieve breakthroughs where you have been unable to?
- Are there traumatic issues you need to work through that require the assistance of a counselor, psychologist, or psychiatrist?

Body

It is important to take care of this one precious body that we have been given. Abusing, ignoring, and running it into the ground will not enable us to live a full and healthy life. I've had various illnesses brought on by stress and my lack of care for my body that ultimately led to being hospitalized or put on medication that made me feel horrible. Every day we must take care of our bodies and pay attention to anything that may negatively affect it.

I know my body doesn't like certain foods like wheat, sugar, and dairy. I love bread. Did I say I love bread? I do, especially if it's warm with butter. I love butter pecan ice cream. But both bread and butter pecan ice cream cause my stomach to become unsettled. To support my body health and weight, I now minimize the consumption of foods that aren't good for me. I occasionally welcome the inevitable discomfort for the sake of satisfying a craving. But I do that only sometimes now. However, whenever I do enjoy food that will cause me discomfort, I know that I'm making a conscious decision and the consequences that come with it.

Consider these questions for taking care of your body:

- Have you had a physical exam or gone to see the dentist in the past year?

- Do you need a massage to release stress?
- When was the last time you took a bath with candles and/or music for relaxation?
- What do you need to do to increase your energy? By the way, the answer is not more tea or coffee.
- Do you have a regular exercise routine to strengthen your muscles and increase your cardiovascular health?
- When was the last time you went for a walk in your favorite outdoor setting?
- Do you need to adjust your schedule or stop watching the late-night programs to get six to eight hours of sleep?
- Is there a family member, friend, or colleague who can be your workout buddy?
- Would you benefit from the help of a nutritionist or personal trainer?

Heart

We need to attend to our emotional needs, the people we hold dear, and the things we are passionate about in life. Sometimes we get so caught up with the demands of life that we discount the importance of doing those things that touch our heart and bring us joy and laughter.

I love cuddling up with my honey and feeling his loving embrace. However, I often get caught up with household or business activities that can wait and miss the window to cuddle because he has gone off to bed. I truly enjoy getting together with my girlfriends, sharing stories, jokes, experiences, and laughing until we cry. But doing so means being intentional and planning girlfriend time. A mile from my house, there is a park with a tree-lined lake and a walking path through the woods that always brings me a sense of serenity amid my bustling life. When I go there, I feel free and rejuvenated.

Consider these questions for taking care of your heart:
- Do you have any close friendships in your life that are mutually supportive?

- Have you opened your heart to being vulnerable, to allow someone to get close to you?
- Are you ready for a committed relationship? Are you in a committed relationship?
- Do you have intimacy in your life (which is not the same thing as sex)?
- Is there anything you are passionate about in your life (Passion is connected to whatever we love doing)?
- Are you doing work or have a hobby that you love?
- Have you resolved outstanding issues with loved ones in your life? They need to first be open to resolving disputes.
- Is there a place (an area, corner, window) in your home that's soothing and restorative?
- Do you need to declutter areas of your home to create a more beautiful or peaceful environment?
- Is there art or music in your environment that speaks to your heart?
- Is there someplace you'd love to visit or something you've always wanted to do that you desire to make happen?
- Is there anything you really enjoy doing that you haven't recently treated yourself to? (I went out for formal afternoon tea alone which I hadn't done in years and it was wonderful.)

Spirit

When I use the word "spirit," I'm referring to the growth of your belief in a power greater than yourself that brings forth peace, serenity, harmony, wisdom, and love from within. Spirit means different things to people depending on your beliefs or what you were exposed to growing up. There are things we can do that are simple and restore, touch, and expand our awareness of something greater beyond ourselves. Whenever I walk, I am in awe of the majesty of nature, the effortless flight of a bird, the quiet graceful flutter of a butterfly, the smell of the delicate honeysuckle plant, and I am at peace and open to connect with God.

- What brings you joy from deep inside? How can you have more of that in your life?
- Are there meditative or mindfulness practices that calm you and bring you peace?
- Do you have inner peace? If not, what can you do to restore it?
- Are there any places you can go to that are a source of peace and serenity?
- Do you regularly read inspirational literature?
- Are you reading the bible or other books that will increase your faith?
- Do you have faith beyond yourself?
- Are you a part of a spiritual community?
- Do you pray?
- Do you have a personal relationship with God?

There are other broad questions you can ask yourself to figure out what you can do to better support yourself. Here are those questions and how I answered them:

1. **In order to accomplish a goal or be successful at something, what do you need to do?**

I have been working on this book for years. Instead of a birthday celebration and gifts, I opted to use the money saved to reserve several days at a beautiful inn that sits on a bay to make progress on completing this book. In a room overlooking the water in a serene environment with no demands or distractions, I was able to finish the first draft of the book. I also asked friends, family, and inn staff to inquire about my progress to build in accountability. I had to make arrangements for family and with clients while I was out of town during the week I chose to go away. All the requests and adjustments were worth the result of me completing a long-time dream.

2. **To reduce stress in your life or pressure on yourself, what do you need?**

I remember a period of time when I was single and traveling 90% of the time for work. I would clean my home during spare moments on the weekend. My mother was a woman of great wisdom who said," You make enough money to hire someone to clean so you can enjoy your precious time off." I didn't take her advice until I broke my right foot (my first of two slow-down breaks). I tried cleaning the house and, as you might imagine, that didn't work too well for me. My leg swelled up to the point of feeling like it was going to burst the cast. That painful experience caused me to finally decide to ease the pressure of cleaning by hiring someone. Many years later, I now have a family that helps because I ask, all right, tell them how to help keep the house clean, and periodically, I'll hire someone to come out and clean.

3. **What do you need to help you through a certain period of life?**

I knew someone who was going through a period of financial difficulty. Deanna indicated she was going to have to drop out of college. Only because she opened-up and shared her challenge did someone step up and give her the money to continue her studies. Jasmine recently lost her Mom and just needed some downtime, but it was not financially feasible to take a vacation. Because she opened up and shared what she was going through, a friend gave her a timeshare week to go away.

4. **Do you need to tell loved ones that you are sick, depressed, or emotionally distraught?**

My own mother suffered silently trying to manage her illness in part because she didn't want to disrupt my very busy life. I found out a month before she passed away how sick she was. However, I was able to be a great support to her in her last days. Yes, I was terribly busy, however, had I known about the seriousness of her condition, I would have rearranged my life to be there for her sooner.

5. **Do you need to cut ties with people, places, or things because they drain you or are in conflict with your beliefs?**

I recall one of those deep loves in my life. This guy had my heart and, for the most part, treated me very well. He was a charmer, flirter, and could make a ninety-nine-year-old woman swoon. He was wired to make every woman he encountered feel good. Over time, it wore on me and I realized I loved him more than I did myself and, in some ways, I worshipped him. I didn't feel good about how I continually felt diminished with him in public and there were also other things he did that I felt were inappropriate, like giving women he worked with red roses and Victoria Secrets lingerie. So, I finally realized I needed to end the relationship. It was hard but necessary for me to reinforce my self-worth.

Ten years into my twenty-year career at P & G, I vowed I would stay as long as I was growing, contributing, making a difference, and enjoying my work. The nineteenth year of employment, my work began to shift. I was doing work I did not enjoy. I had a lucrative salary, great benefits, and job security which were key for me as a single mom. I found out that the portion of work I didn't like was increasing from 20% to 50% of my responsibilities. I wanted to be happy and provide a sound role model for my daughter by doing work that I loved versus staying for the salary. I valued the support system where I lived and needed to reduce my amount of travel, so I decided to leave. It was a very hard decision that resulted in tough times including, at one point, making about 30% of my former salary. Still, I have never regretted the decision to have my values aligned with my choices.

There may be people, places, or things you need to let go of to move forward in your life

To answer any of the five questions, you must let yourself be vulnerable, put aside your pride, and have hard adult conversations. No, it's not easy. Yes, sometimes you have to garner the courage to ask for what you need. It is up to you to believe that you are worthy of someone's efforts, time, resources, love, and support. Trust me, girl, as long as you live and breathe, you are worth it!!!

Reflections

You read some examples about considering your needs for support. Now it's your turn to answer the same questions about yourself.

1. What do you need to do in order to accomplish a goal or be successful at something?
2. What do you need to reduce stress in your life or pressure on yourself?
3. What do you need to help you through a certain period of life?
4. Do you need to tell loved ones that you are sick, depressed, or emotionally distraught?
5. Do you need to cut ties with people or places because they drain you or are in conflict with your beliefs?

Reflections

CHAPTER 14

Know Your Greatest Sources of Support

"We should always have friends in our lives. One who walks ahead who we look up to and follow: one who walks beside us every step of our journey; and the one who we reach back for and bring along after we've cleared the way."

MICHELLE OBAMA

When you are trying to keep up with the hectic pace of life, you can become oblivious to recognizing the sources of support that are around you. Try to become aware of and tap into your greatest sources of support. Four great ongoing sources of support are yourself, family, close friends, and God.

Yourself

The first source of support always at your disposal is you! Yes, I said, "you!" Being a great support to yourself means loving yourself unconditionally when you're both proud of yourself and when you're falling short of what you want to be. It means believing you are deserving to receive what's best for you. It's realizing that asking others to support you, be it emotionally, physically, financially, etc., is not shameful or weak.

It means practicing positive reinforcement by saying good things to yourself and about yourself. In the movie "The Help," the character Aibileen Clark, played by Viola Davis, said to the little girl Skeeter,

played by Mae Mobley, "Remember to tell yourself, you is smart, and you is kind, you is important." I say to myself "I am fearfully and wonderfully made and worthy of more goodness than I can ask for or imagine." Well, my sista, it's time to create your phrase to repeat that reminds you of how special and worthy you are.

Family and Friends

As adults, we often feel that we need to handle our lives on our own. I shake my head because every day I need to acknowledge the lie in that sentiment. We are nothing without those who contribute to our lives. The deposits others can make into our lives could come in the form of basic nurturing, words of wisdom, resources to sustain us, or help to do something. What we need to understand is that the people in our lives, those who we are in close relationship with, are truly there for us.

Support can come from a parent, sibling, cousin, aunt or uncle, niece or nephews, or your children. It may come from friends, new and old. While all family and friends won't be your sources of support, there will be a select few who would do anything for you because they care for you. You only have to ask.

My husband Joseph is amazing and often says, "baby just tell me what I can do to help." Sometimes I don't say what I need. I guess I expect him to read my mind. Truthfully, many of the men in our lives really want to help us, but they need direct instructions about how to help. My husband genuinely wants to make my life easier, better, and more for fulfilling. I know this so I continue to practice being more accepting and asking for what I need.

My daughter will do anything to help me out. What I had to realize was that, when she was a teenager, getting her help required that I continually remind her. Ultimately, though, she would do whatever I asked. She's older now and she can anticipate my needs whenever she's back home. Even, still, I can't always rely on her to know if I need help or not. I still have to ask.

My closest girlfriends are a core group of women who have been in my life ranging from childhood to the last several years. They would do anything for me. They have teamed up with each other to help me

out when needed, and they are there to support me individually when I let them know how I need them. Three of my friends, Cathy, Nancy, and Sabrina, who I went to graduate school with, have often come to my aid before I could even ask. I know they will always unconditionally be there for me.

My mother was one of the most selfless people I knew. She was always giving and helping others. While she didn't ask others to do things for her, she was often available to provide any assistance she could for someone else. Knowing she was always there for others, I rarely asked her for any assistance and often refused when she offered. I deprived her of opportunities where she wanted to be a blessing to me. I was twenty-four when I bought my first home and she wanted to help me with the down payment. Because of my pride, I told her "no." Her grandmother had helped her by a home. With me, she just wanted to pay forward the kind gesture. With my "no," I deprived her of contributing to my life. That is what you can sometimes do when those in your corner want to support you.

The key to connecting to our greatest sources of support is to communicate how we need friends and family in our lives to enhance, help out, or contribute to our lives.

Reliance on God

I truly believe that my greatest support comes from God. I have found strength and hope through God and I have experienced miracles from having faith in something beyond my mere human existence. People will unintentionally fail you and fall short of your expectations, but God is always been ever present for you.

There have been many times in my life when I called out for help and have never been failed. When I was in my twenties, I got tangled up in drug use. Nobody knew I was struggling. I called out to God asking for help, to free me of my desire for drugs. That was decades ago and I am still drug free.

When I was pregnant and bleeding profusely, the doctors had given up. So, I cried and prayed and my daughter was saved. I was on bed rest and was told by the perinatologist for high-risk pregnancies that my daughter would be born with health issues and potential deformities.

I prayed to God daily and today my daughter is a healthy, wonderful, loving, intelligent and successful young woman.

After being diagnosed with sarcoidosis, I was told that I would probably have a very limited life and have to use an oxygen apparatus. I prayed to God for healing and I have not had any flair ups with the disease since 1996. Today, I lead a full, active, and healthy life.

As a single mom having started a business, I wondered several times if I should get a job. I asked God to bring business and soon after opportunities opened up.

I share these stories to show that God is waiting and wants to have a personal relationship with you. God is waiting on our requests or prayers that are aligned with his good and perfect will for our lives. Even God must be asked to work in our lives which is the essence of prayer. It's a matter of choice. We can choose to take things in our own hands or ask God through prayer to intercede according to his good and perfect will in our lives. God is available to support us from our minor needs to major problems that come up in our lives.

Whatever your needs are, they are not too insignificant for God. Learn about God's characteristics and how God desires to move in your life. Seek Him, read the word about Him, and find out what the promises are concerning you.

Discover and tap into the abundance of ongoing, ever-present support available to you through yourself, friends, family, and finally God!

My sista, go on and be in support of yourself!

Reflections

- What do you need to say to yourself for yourself to receive support in your life?
- Who are your core family and friends who are there to be sources of support for you?
- What do you need to do to build a personal relationship with God?

Reflections

Thank You

My Dear Sista,

From the depths of my heart, thank you for using your invaluable time to read this book. It has been a labor of love intended to help you have a more fulfilling life journey. It is my hope that you received some insights on how to be more in support of yourself.

If you have questions, want information about future workshops, retreats, speaking engagements, etc., please email me at
info@cherylgrayhines.com

Be in Support of Yourself,

Cheryl

Acknowledgments

thank God for the inspiration to write this book and the journey to give me insight about how to be in support of myself. I know each of you who have encouraged and assisted me in finishing this book was heaven sent and I thank God for each of you.

Joseph, you are truly my blessing beyond what I could have ever asked for hoped or imagined. You inspire me to step into my destiny and encourage me to release whatever impedes my progress. Thank you for the trips away to have the solitude to write without distraction surrounded by nature. You always encouraged me to feed my soul and pamper my body while writing. You truly love me in a way that helps me to be my best in life. I could not have fulfilled this dream without you and love you with all of me.

Alessandra, you are an amazing, beautiful, smart, creative woman with a generous heart. I am blessed to be your Mom. I was inspired to share these concepts because I want you to become as open to receiving as you are zealous in doing for others.

Shannon, you are love, laughter, light and smarter than you know. You remind me of the importance to always be in support of yourself.

Alice and Percy, you have inspired me with the books you have written and zest for life. Thank you for the encouragement to pursue new endeavors to impact others. Love you!

Big Sis Joy, I chuckle at your New York frankness always telling me to make my dreams a reality with a solid plan. Thank you for always pushing me to go beyond where I am comfortable.

Thank you, Audrey, Carol Ann, Cathy, Cheryle, Claire, Debra, Denise, Gloria, Izetta, Jackie, Judy, Marlene, Nancy, Precious, Sabrina, Suzanne, Vanessa, Wanda, and the many others that encouraged me to voice my perspective about a topic of struggle for many women. Your support,

guidance, wisdom, love, and friendship touch my heart.

Lane, you jump started me getting back to writing and overcoming writer's block with your online workshop. Thank for the difference you have made in my life.

Jacquie, thanks for filling the blanks from my handwritten notes, proofreading the rough draft, and encouraging me to press on and get this done.

Carmelle, thanks for creating a cover that invites the reader into a special place to support themselves before they even open the book. I am grateful for your creativity, love and support.

Todd Hunter, my editor, you asked me thought provoking questions that developed my voice. You suggested modifications to make the book more reader friendly, made it easier to write, gently encouraged progress and coached me regarding the publishing path forward. I could not have birthed this book without you. Thank you!!!

Janice, who I lovingly refer to as JB, was always in my ear to finish this book. She was a constant source of encouragement and steadfast prayer partner until she went to heaven. You are forever in my heart.

About the Author

Cheryl Gray Hines is an accomplished entrepreneur, executive coach, and mentor with a mission to support women to live authentically and be their best. Her candid and compassionate approach leads women to actualize their desires. She is the founder of C. Gray & Associates where she advises companies on organizational leadership, integrity, and effectiveness. She loves being a wife, mom, and entrepreneur. Cheryl resides in Maryland with her husband.